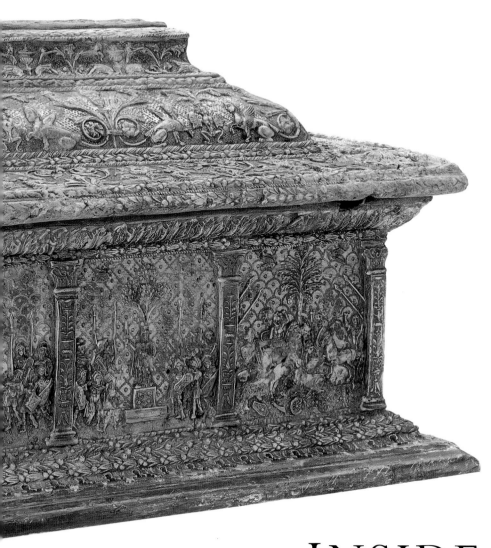

INSIDE THE
RENAISSANCE
HOUSE

Il piano della strada il terreno
della casa che abita mona......
dagadi alla casa grande eti
piu basso $6\frac{1}{4}$ in circa ala tizioni
cioe il piano della sala epiu basso
6.2 el secondo piano pibasso
$6.3\frac{3}{4}$ elaltro piano e piu basso
$6.4\frac{1}{3}$ che rasente il tetto ——

abla casa congiusta

A piani della casa sono alti
1.mo al piano della via si troua
piu basso circa $\frac{1}{2}$ di 6 al $\frac{1}{2}$
al piano della sala si troua
piu baso il simile cioe $6\frac{1}{4}$
elultimo al piano dele chiesa
alesquine sono delpari et qui nel
profilo enotato tute le alteze
della casa grande ——

La casa del pilj al piano dela
strada si troua piu baso che
quelo dicasa $6\frac{1}{2}$ el 2
si troua piu baso $6\frac{1}{2}$ il 3
si troua piu baso $6.4\frac{1}{4}$ elaltro
e il tetto ————

E casa di salorenzo si troua
al piano della via al me desimo
piano piu bitto piu alto, o

guardaroba

66

66

66

65

Camera $6.7\frac{1}{4}$

Camera 6.8

no 2

6.5

casa del
g. Ej

ELIZABETH CURRIE

Inside the Renaissance House

V&A PUBLICATIONS

First published by V&A Publications, 2006
V&A Publications
Victoria and Albert Museum
South Kensington
London SW7 2RL

Distributed in North America by Harry N. Abrams, Inc., New York

ISBN-10 1 85177 490 4
ISBN-13 978 1 85177 490 6
Library of Congress Control Number 2006928679
10 9 8 7 6 5 4 3 2 1
2010 2009 2008 2007 2006

A catalogue record for this book is available from the British Library.

Every effort has been made to seek permission to reproduce those images
whose copyright does not reside with the V&A and we are grateful to
the institutions and individuals who have assisted in the provision of
photographs for this book and the exhibition *At Home in Renaissance Italy*.
Any omissions are purely unintentional, and the details should be addressed
to V&A Publications.

Designed by Nigel Soper after an initial design by Harry Green
New V&A Photography by Christine Smith, V&A Photographic Studio

Front jacket illustration: *The Birth of the Virgin* by Andrea del Sarto. Fresco,
 1514, SS Annunziata, Florence
Back jacket illustration: 'January', from an album of *Designs for
 The Twelve Months*, by Antonio Tempesta. Italian, 1599
Frontispiece: Cross-section of the Gaddi House, Florence (see p.13)
Plates 3, 8, 9, 10, 23, 36, 37, 38, 48, 53, 54, 62, 78 ©1990 Photo: Scala,
 Florence

Printed in Hong Kong

V&A Publications
Victoria and Albert Museum
South Kensington
London SW7 2RL
www.vam.ac.uk

CONTENTS

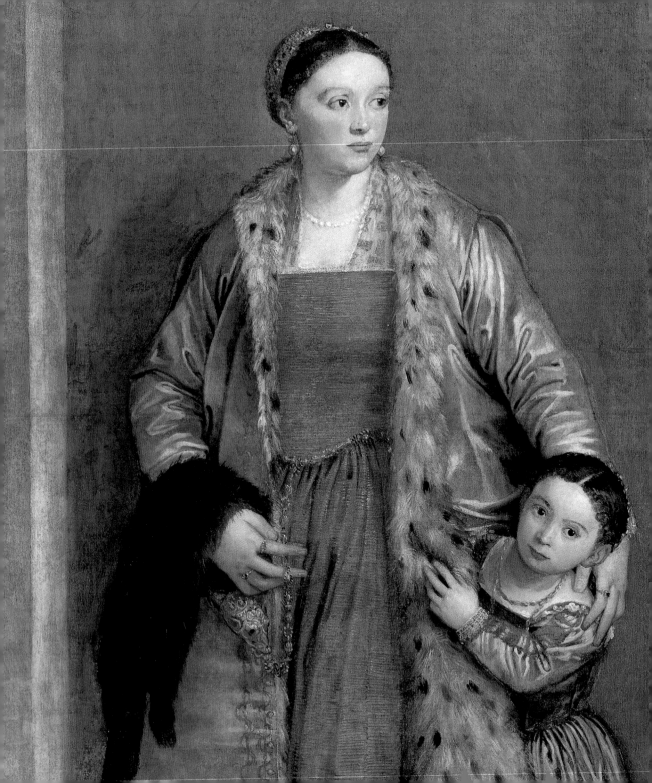

A VIEW INTO THE RENAISSANCE HOME

As the city was besieged by imperial troops in 1529, a group of Florentines visited the house of Margherita Acciaiuoli, taking advantage of the absence of her husband, the merchant Pier Francesco Borgherini. Their aim was to purchase and dismantle her bedroom, which included a famous series of painted wall panels, in order to present its contents to Francis I, king of France, with the consent of the Florentine government. Margherita successfully opposed the plan, fiercely declaring that:

> …this bed is my wedding bed. My father-in-law, Salvi, commissioned it to honour the occasion of our marriage, along with the rest of these magnificent and regal furnishings. I cherish them in his memory, and for the love of my husband, and mean to defend them with my own blood and with my life itself.

This dramatic episode, described by the art historian Giorgio Vasari, reveals the importance of domestic surroundings during the Renaissance, when household decorations were treasured not only for their beauty and financial worth but also for the stories they told about family life.

Across the cities of northern Italy, many powerful individuals, who had made fortunes in trade and banking, chose to channel notable

PREVIOUS PAGES:

1. Paolo Veronese, *Portrait of Countess Livia da Porto Thiene and her Daughter Porzia.* Oil on canvas. Venice, *c*1551. Walters Art Gallery, Baltimore, 37.541

2. Paolo Veronese, *Portrait of Count Iseppo da Porto and his Son Adriano.* Oil on canvas. Venice, *c*1551. Palazzo Pitti, Florence, inv. Contini Bonacossi no.16

OPPOSITE:

3. Photograph of the Strozzi Palace, Florence

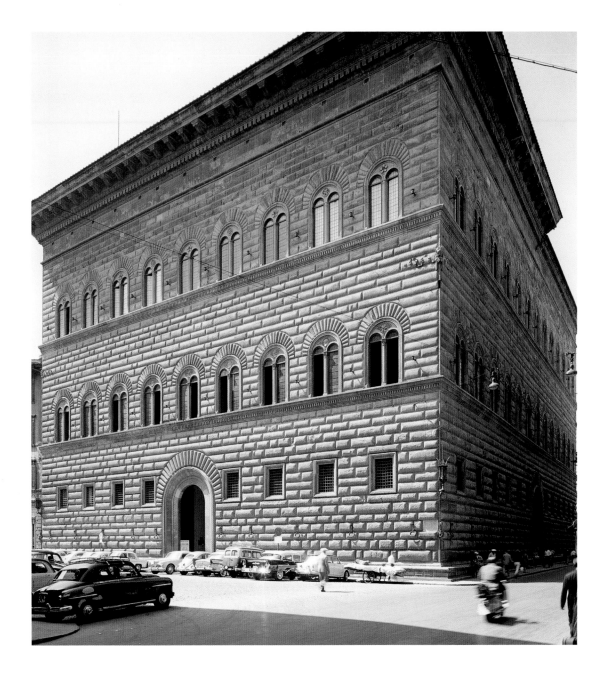

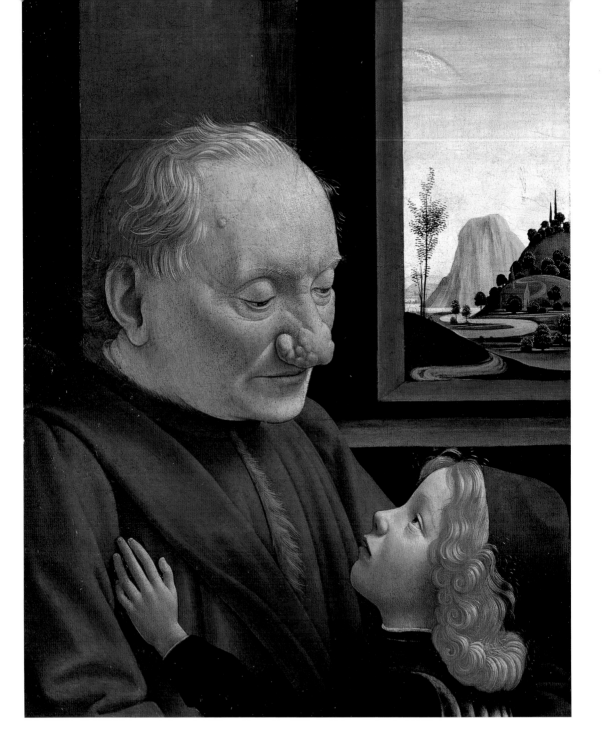

sums of money into creating the perfect home. They built imposing residences, which radically altered the urban landscape. In Florence, whole areas of the medieval city were knocked down in the fifteenth century to make way for family palaces, such as those belonging to the Strozzi and Medici (plate 3). Often emblazoned with coats of arms or other family devices, these houses were designed to proclaim the status and identity of their inhabitants to the wider community. As families grew more concerned with the need to preserve their wealth, the home represented the ultimate worldly good to be safeguarded. Ideally, it was passed down from one male heir to the next, and different generations, including grandparents and grandchildren as well as siblings and their respective families, tended to live together in large, patrician houses (plate 4). Such groups could be very close-knit, since family members were often partners in business, particularly in mercantile Florence and Venice. Some houses were divided up to give these different occupants their own living quarters, ranging from a spacious set of rooms, or apartments, used by the head of the family and his wife, to a single room for an unmarried son.

Renaissance houses were a hive of activity. As well as providing accommodation for extended family groups and their servants, some also contained displays of renowned collections of paintings and precious objects or offices used for commercial purposes. Many houses were production sites, where quantities of linen were spun and woven for domestic use. A family palace was typically arranged on three floors. The ground level often included a courtyard and loggia, as well as service areas, such as a laundry room, and stores for firewood, food, wine and other provisions. In Venice, where space was more of a luxury, it was not unknown for family members to inhabit the ground floor. In both cities, the first floor, or *piano nobile*, boasted the most elegant apartments, and the more cramped servants' quarters were located underneath the roof. As a cross-section of the house of the Florentine Gaddi family illustrates, the reception room – or *sala* – was frequently situated at the front of the building, while more private rooms, such as bedrooms – or *camere* – were at the back (plate 5). Before the fifteenth century, rooms were multi-functional and

4. Domenico Ghirlandaio, *Portrait of an Old Man and his Grandson*. Tempera on panel. Florence, c1490. Louvre, Paris, R.F. 266

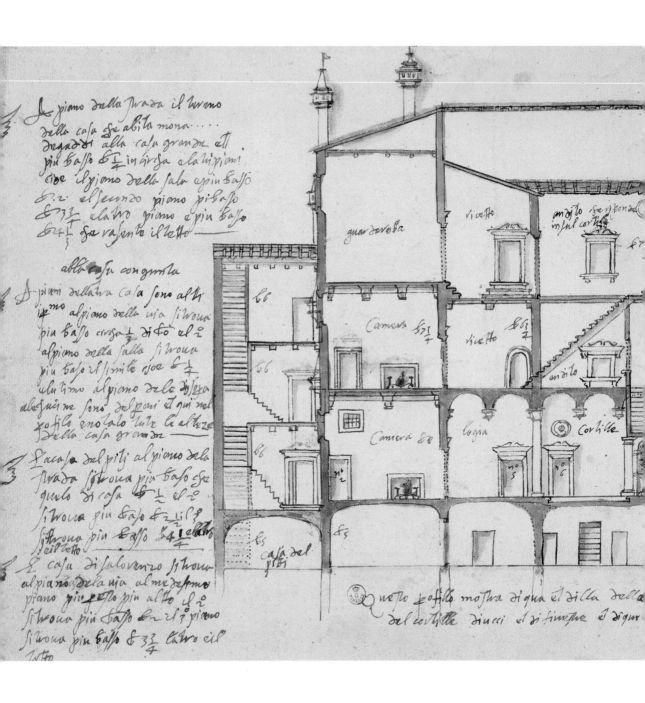

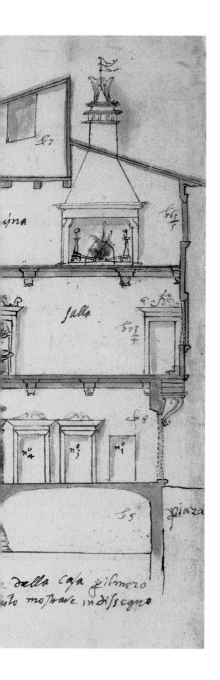

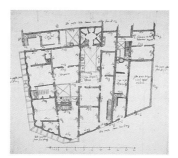

5. Unknown draughtsman, *Cross-section and plan of the Gaddi House, Florence*. Brown ink with brown, green, red, yellow and blue wash on white paper. *c*1560. Uffizi, Gabinetto dei Disegni e Stampe, Florence, n.4302 A

often very bare. Most pieces of furniture and valuable possessions were concentrated in the bedroom. Over the following two centuries, however, other household rooms also became more carefully thought out and developed their own distinctive character. Some were used more by men than women, and vice versa. As each room led on directly to the next, some parts of the house were necessarily more public than others. So while certain rooms might have been the favoured setting for important family celebrations, others were occasionally reserved for the use of just one individual.

Funding building projects, even private ones, was traditionally seen as an honourable and worthy activity and this view was gradually extended to encompass the furnishing of the interior. The relationship between family identity and the home did not just stop at the façade. The rise of domestic architectural projects was soon complemented by treatises that discussed the ideal layout for rooms and the arrangement of domestic furnishings. Practical advice was offered regarding all areas of home life, from how to buy foodstuffs down to the correct way to use a napkin. During the Renaissance, it was commonly acknowledged that possessions transmitted strong messages about their owners. It was thought, for example, that a person's appearance mirrored their character. For this reason it was important to dress well, according to one's social status. Black was a sign of sobriety and good measure, and someone who combined too many different colours in one outfit risked being seen as frivolous and erratic (plates 1 and 2). In a similar way, household objects, from

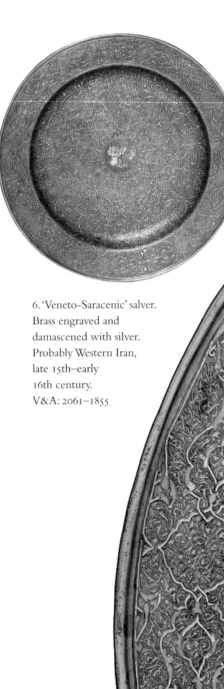

painted chests and ceramic dining sets to woven wall hangings, could contribute to a family's reputation and indicate their social standing and refinement.

Given that there were such strong incentives to give or acquire beautiful things for domestic use, it is hardly surprising that one of the defining features of the period was the development of new types of furniture, paintings, eating utensils and so on. Many of the paintings that we now associate most with the Renaissance began their lives in a domestic setting, perhaps as part of a marriage chest or the headboard of a bed, and artists who painted frescoes and portraits were equally comfortable making designs for embroideries or silverware. Observers, who frequently noted with disapproval the fashion for silks, gilded ceilings and lavish table settings, remarked on the growing splendour of patrician interiors. Some of these goods filtered down from the wealthy to other social groups. Perhaps made of cheaper materials, or with a slightly different form, they nevertheless had an enormous effect on the ways people ate, drank, interacted socially and conducted their day-to-day lives.

Italy's geographic and economic conditions meant that it was uniquely placed to encourage this consumer revolution. All the larger urban centres were famous for some form of craft production, and competition forced each one to develop its own individual style. Italian artisans were highly skilled in adapting to and fuelling demand: if an object became fashionable, it was soon available in seemingly limitless variations. Many Italian cities enjoyed strong trading links with other European and Eastern countries, increasing the availability of foreign objects for the home. Goods imported from the Levant, such as brass vessels decorated with Islamic motifs and inlaid with silver, were particularly popular in Venice (plate 6). The obvious attraction of such products spurred on Italian craftsmen to

6. 'Veneto-Saracenic' salver. Brass engraved and damascened with silver. Probably Western Iran, late 15th–early 16th century. V&A: 2061–1855

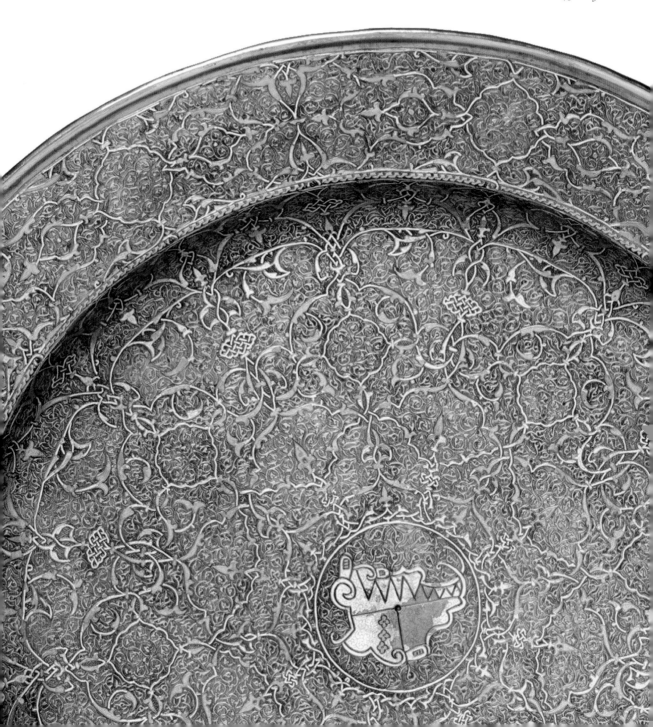

7. Inventory of Francesco Nori's
house, Florence.
Pen and ink on paper. 1478.
Archivio di Stato di Firenze,
Magistrato dei Pupilli avanti il
Principato, vol.174

imitate new and unusual techniques. So domestic interiors often combined an eclectic range of furnishings, some of which were inspired or created by other cultures.

Many types of evidence survive to take us inside Renaissance homes and rediscover the people who created and inhabited them. Italians wrote meticulous inventories, listing entire household contents down to the very last pot and pan (plate 7). These were generally compiled after the death of a family member and served partly to protect inheritances. Authors of books on travel, art, history and numerous other subjects described the appearance of interiors. Artists often chose to depict these new and striking spaces, in some cases to give religious compositions a contemporary setting and a sense of immediacy. Above all, pieces of furniture, paintings and textiles have survived over the centuries. Almost all the objects we see now have experienced many different lives and have travelled far from their original, domestic settings. Many have changed dramatically over time: countless prints and books have been cut up and the painted panels of chests removed, part of a pattern of recycling that began during the Renaissance itself. In addition to their aesthetic value, domestic goods were also important financial investments, so that expensive curtains or bed covers were turned into clothing rather than thrown away, and metalwork was sometimes melted down and recast according to changing tastes. If objects were sold, it was not unusual for the new owners to have them decorated with their own coat of arms or even their initials. These ongoing interventions remind us of just how far Renaissance Italians identified with the possessions that furnished their homes.

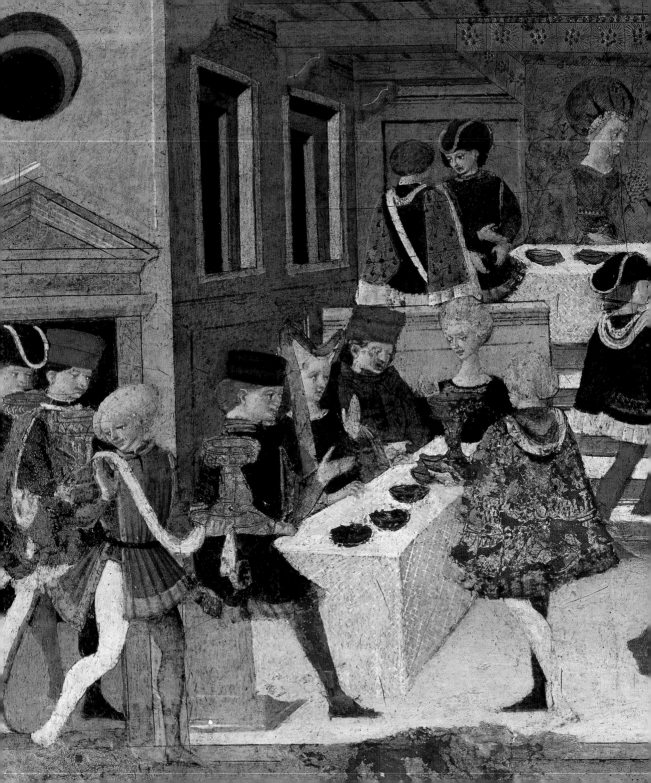

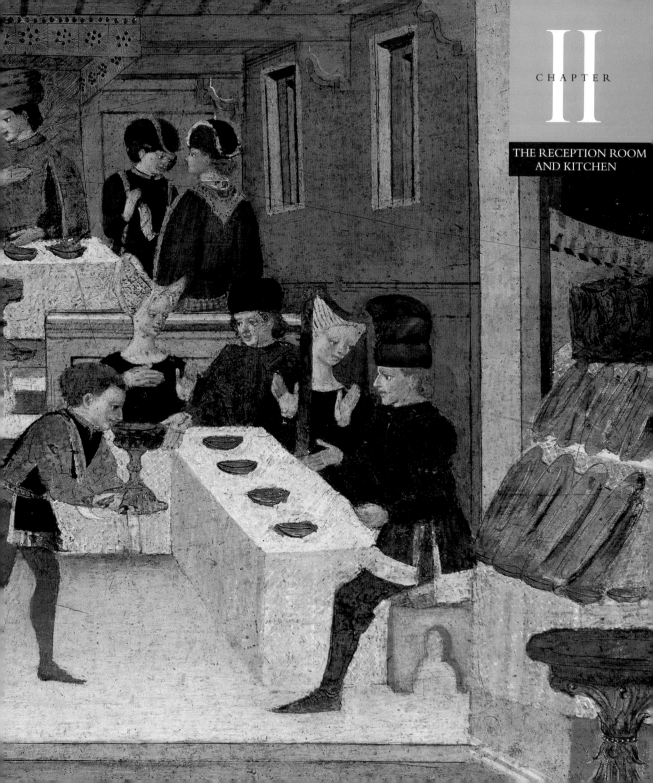

THE RECEPTION ROOM AND KITCHEN:
The Social Life of the Family

THE RECEPTION ROOM, known as the *sala* in Florence and *portego* in Venice, was usually the largest room in the house and was located on the first floor at the front of the building, directly above the main entrance. As a result, it was easily identifiable from the street. Reception rooms were also the 'eyes' of the household and provided the family with a view onto public life. From their windows, it was possible to follow events that took place in the street or, in Venice, along one of the canals, such as processions, sporting events and political celebrations. This aspect was particularly valuable for female members of the family, given that they rarely had an active role to play on such occasions. The close relationship between interior and exterior worlds is suggested by the row of empty windows, hung with household objects, in the middle of the building overlooking the square in a scene of Florentine life by Masolino da Panicale (plate 9).

With large windows and a higher ceiling than the rooms on the floor above, the *sala* was a big, well-lit space, a characteristic that was at least as important as the objects it contained. In Venice, the reception room often ran from the front of the house right to the back, so that it was lit by windows at both ends. The strong natural light was typically enhanced by *terrazzo* flooring, a very polished, reflective surface made of different-coloured marble chips. The high position of the windows in many reception rooms left a large amount of wall space, which could be decorated with paintings or textile hangings, as shown in a depiction of the

PREVIOUS PAGES:
8. Apollonio di Giovanni, *The Story of Alatiel: The Wedding Banquet.* Tempera on panel. Florence, *c*1440–60. Museo Correr, Venice

9. Masolino da Panicale, detail from *The Healing of the Lame Man and the Resurrection of Tabitha.* Fresco. 1426–7. Brancacci Chapel, Chiesa del Carmine, Florence

Wedding Feast at Cana by Alessio Baldovinetti (plate 10). Wooden ceilings were often brightly painted, drawing the eye upwards. The intentionally impressive nature of the room was further under-lined by a variety of architectural elements, such as cornices or heavy stone door frames, topped with portrait busts (plate 11). Stone fixtures, such as built-in wall-fountains and fireplaces, were a striking feature of Florentine reception rooms. In the grandest

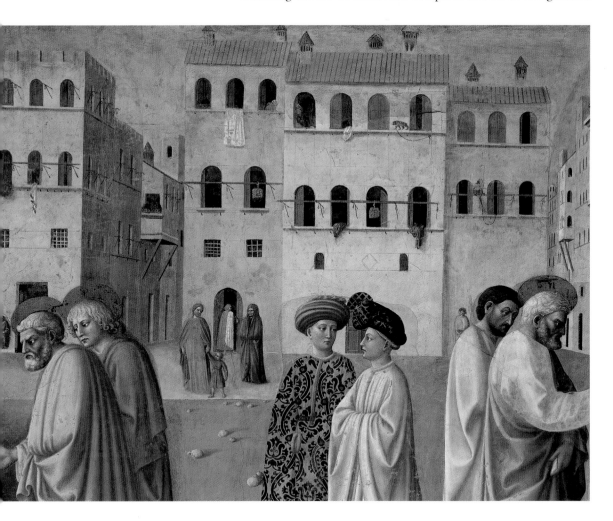

10. Alessio Baldovinetti, *Wedding Feast at Cana*. Tempera on panel. Florence, *c*1449. Museo di San Marco, Florence

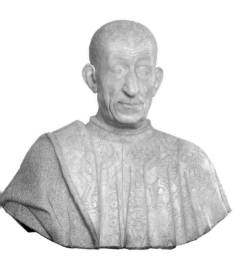

11. Benedetto da Maiano, *Bust of Pietro Mellini*. Marble. Florence, 1474. Museo del Bargello, Florence, Inv.52s

12. *Acquaio* from the Girolami Palace, Florence. Pietra serena. *c*1500. V&A: 5959–1859

Florentine homes, these were huge architectural structures, like this wall-fountain from the Girolami family palace that reached almost to the ceiling (plate 12).

The reception room was the main location in the household for entertaining and receiving the outside world. Some rooms

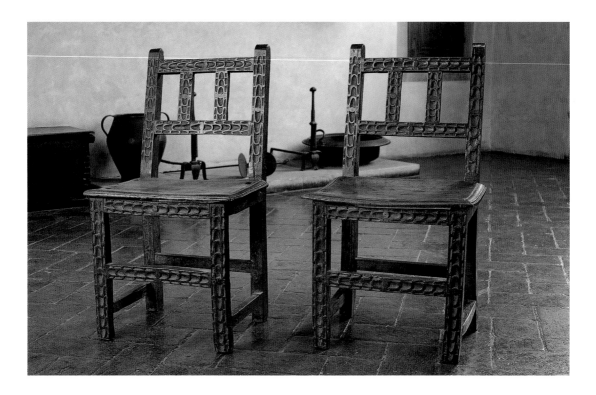

13. Pair of chairs.
Carved walnut. Tuscan,
16th century. Horne Museum,
Florence, 152 and 696

were designed to be able to host big gatherings of people. These could be for family events, such as wedding banquets and funeral wakes, as well as political ones, for members of the elites were sometimes called on to entertain and provide accommodation for visiting foreign dignitaries and their entourage. The *sala* contained serviceable pieces of furniture, including tables, benches, stools and chairs. Over the course of this period, chairs became more specialized in order to suit particular functions, including ones intended solely for use by women. X-frame chairs were more widespread than ones with arms and backs. Nevertheless, it was the latter, a simple design developed during the fifteenth century, that has remained in use until the present (plate 13). Tables were basic constructions but were decorated to suit the occasion. They were usually covered with fine, white, Flemish or Italian linen

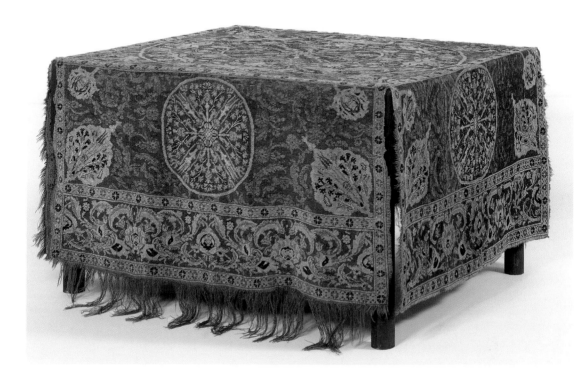

14. Table carpet.
Knotted wool. Probably Cairo,
mid-16th century. V&A: 904–1897

tablecloths, placed over the top of brightly coloured woollen table carpets, often imported from Turkey or Spain (plate 14). All these objects were easy to move, so that the entire space could be quickly transformed whenever necessary. With tables and chairs lined up around the sides of the room, for example, it became the ideal setting for the dances that were an important part of Venetian wedding festivities.

The *sala* therefore presented an opportunity to manifest the importance and unity of the family to visitors. Some objects were marked with family emblems: heraldic devices were carved onto the backs of chairs or painted on the sides of chests. In Venetian reception rooms, it was customary to hang decorative arrangements of armour and weapons on

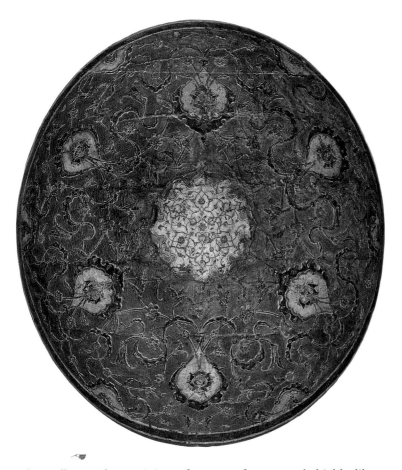

15. Foscarini shield.
Gilded leather. Venice,
1550–1600. Armeria del Palazzo
Ducale, Venice, Inv. J13

the walls, mostly consisting of groups of spears and shields, like this example in gilded leather showing the arms of the Foscarini family (plate 15). Such displays were intended to highlight the military exploits of either the current occupants of the household or their illustrious ancestors and functioned as a symbol of familial honour. Some types of textile hangings also contained carefully placed visual links with their owners, such as coats of arms. After silverware, jewellery and clothing, textile furnishings were usually the most valuable possessions belonging to a family. They were not always kept on display but were changed according to the time of year, and some were taken out only for special occasions. Tapes-

OVERLEAF:
16. Tapestry. Wool and silk.
Brussels, late 16th–early 17th
century. V&A: 129–1869

tries had traditionally been linked with royal patronage and at the end of the sixteenth century still only the wealthiest could afford them. Like this example, part of a set of five owned by the Venetian Contarini family, they were often imported from the Netherlands (plate 16). The subject matter of the Contarini tapestries succeeded in combining two aspects of sophisticated living, by showing leisure pursuits in an outdoor setting and alluding to the ideals of classical antiquity with figures dressed in Roman togas. The tapestries also reflected the widespread taste for hangings decorated with flowers and foliage, which brought a feel of the countryside into urban homes. The very presence of such prestigious furnishings advertised the standing of the owners, even more so when they were specially commissioned to include the family's arms, as in this case.

Coats of arms were not the only way of personalizing interiors. With the development of portraiture in the fifteenth century, household walls began to be decorated with the likenesses of family members themselves. The portrait was one of the many new types of secular art that flourished during the Renaissance. It had particular appeal for wealthy individuals with large homes to decorate and a desire to demonstrate the nobility of their family line. In the sixteenth century, portraits often contained carefully detailed depictions of clothing, in order to indicate the exact social position of the sitters. This strategy is very apparent in Lavinia Fontana's portrait of members of the Bolognese Gozzadini family, seated as they might have been to greet an important visitor into their home. In fact, neither Ulisse Gozzadini, the father, nor his daughter Ginevra, whose arm he touches on his right, was alive when the portrait was painted. In this way, portraits often acted as a form of memorial, providing a record of family groups that no longer existed (plate 17).

Portable furniture and a relatively sparse layout meant that the *sala* could be used for a variety of domestic pursuits, many of which developed their own forms of material culture. Given that large family groups often occupied patrician houses, it was necessary to have at least one room where all members could gather

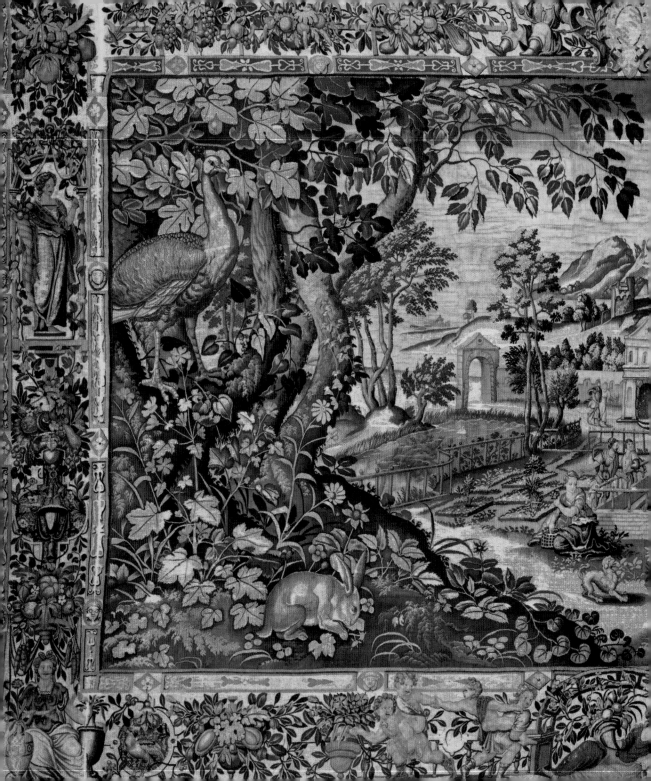

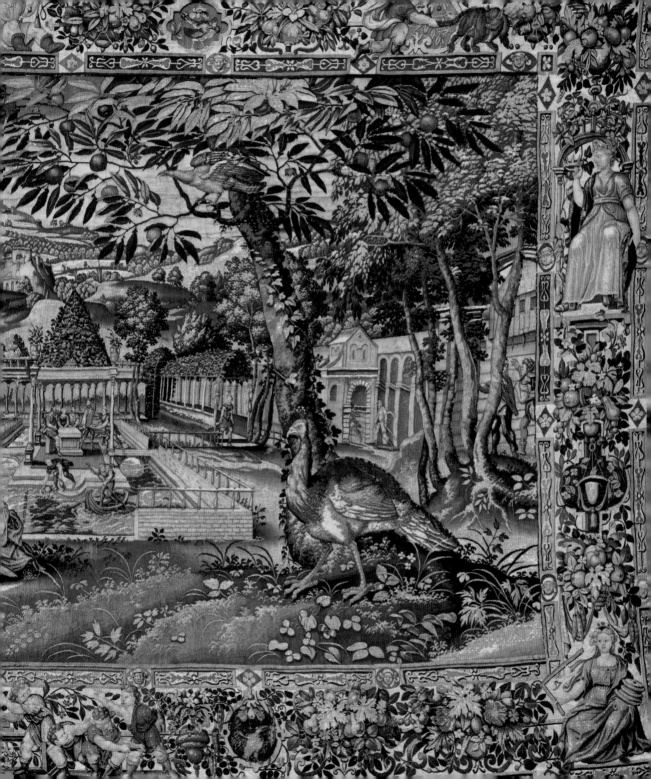

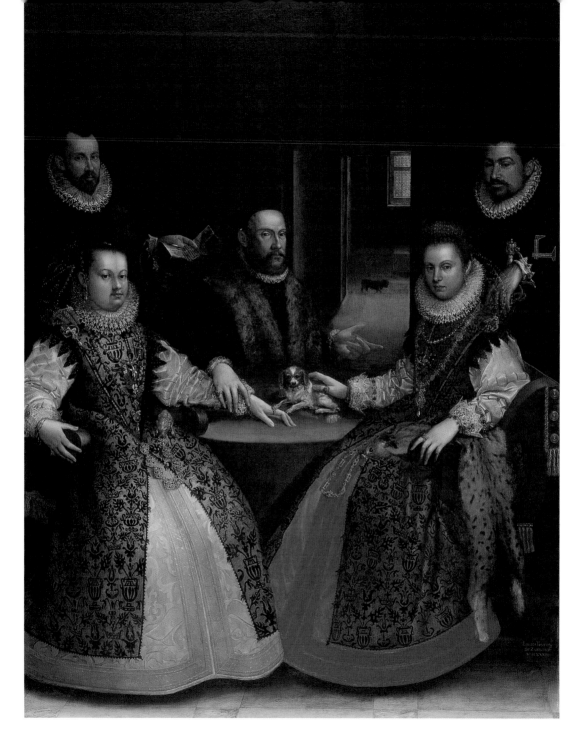

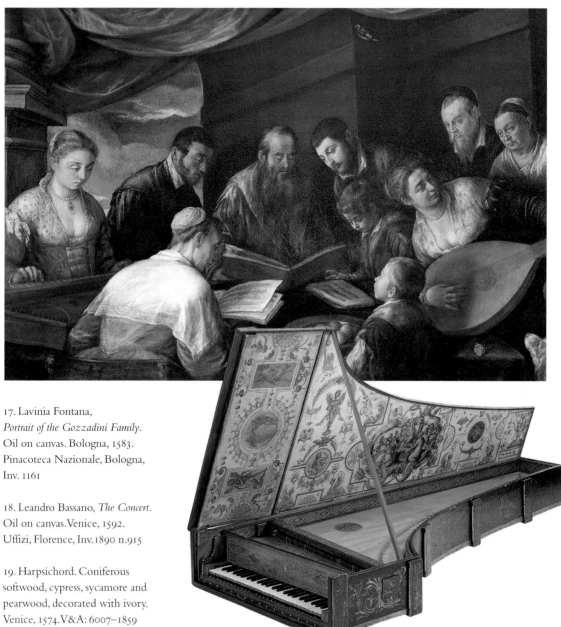

17. Lavinia Fontana,
Portrait of the Gozzadini Family.
Oil on canvas. Bologna, 1583.
Pinacoteca Nazionale, Bologna,
Inv. 1161

18. Leandro Bassano, *The Concert*.
Oil on canvas. Venice, 1592.
Uffizi, Florence, Inv. 1890 n.915

19. Harpsichord. Coniferous
softwood, cypress, sycamore and
pearwood, decorated with ivory.
Venice, 1574. V&A: 6007–1859

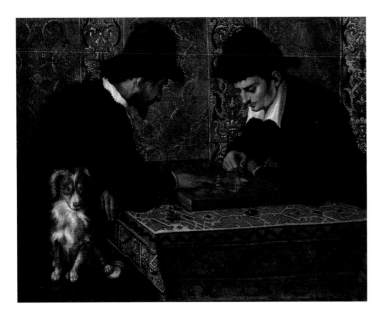

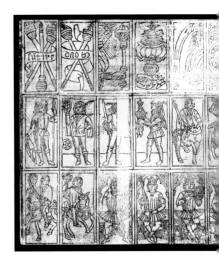

together, and the *sala* generally offered this communal focus. Music was an important part of domestic life, so much so that it was more common to find musical instruments than books in the homes of Venetian citizens. A painting by Leandro Bassano shows three generations of a family putting on an impromptu concert in their home (plate 18). Professional musicians, hired for the evening, often accompanied informal dinners held among friends. Larger musical instruments, such as this harpsichord, would probably have found a permanent home in the reception room (plate 19).

On an everyday basis the *sala* was occupied by smaller family groups, often engaged in different pastimes. Here, the ladies of the household would have caught up with their sewing, perhaps assisted by a female servant. Another family member might have read aloud to make their work more agreeable, while in another corner of the room a game of chess might have taken place (plate 20). Leisure time was filled by a great variety of games, which ranged from the innocent to the ribald or even illegal. Gambling was very widespread, particularly in the form of card games (plate

20. Ludovico Carracci,
Two Chess Players.
Oil on canvas. Bologna, *c*1590.
Gemäldegalerie, Berlin

21. Sheet of 18 playing cards.
Woodcuts. Italian, 1462.
Museo Fournier de Naipes de
Alva, Spain

21). It was very much a family activity, so much so that placing bets on the sex of the baby of an expectant friend or relative became so popular that it was repeatedly banned in some cities. Dice games were also common, including *Pela il Chiù*, or 'Pluck the Owl', which was played with three dice. Players either had to pay or collect money from the pot, depending on where they landed. The outer ring of the board shows familiar figures from urban life, including tradesmen providing household services: chimney-sweeps and street sellers of water, fans, glasses and so on (plate 22).

22. Ambrogio Brambilla, *Pela il Chiù* ('Pluck the Owl'). Etching and engraving. Rome, 1589. British Museum, London, 1869-4-10-2460

Even though eating was not restricted to one particular room in the house, during the Renaissance the *sala* became the usual location for dining, especially for important occasions (plate 8). This was partly due to the growing prominence of the *credenza*, a piece of furniture rather similar to a modern-day sideboard or dresser, which was used to display tableware and generally located in the *sala*. Originally, the *credenza* was simply a table where food was carved and distributed. It took its name from the taster, or *credenziere*, who tried food before it was served in order to make sure that it had not been poisoned or in any way contaminated. Grad-

23. Andrea Boscoli, *Wedding Feast at Cana*. Oil on canvas. Florence, 1580–85. Uffizi, Florence.

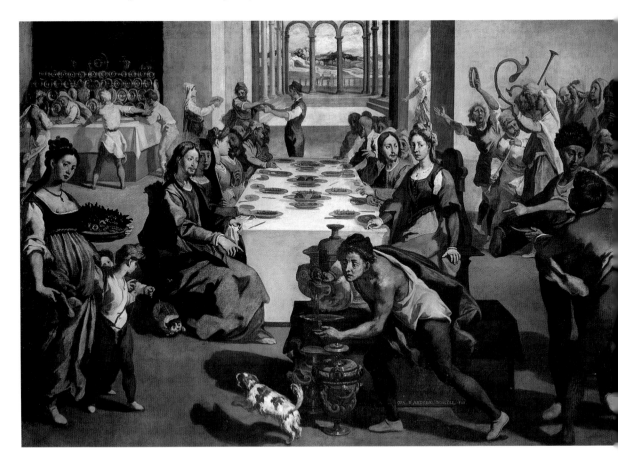

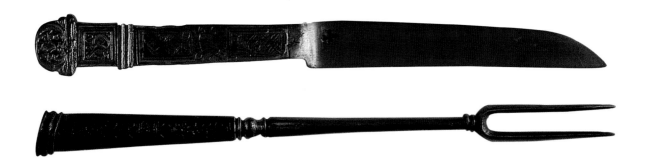

24. Knife. Silver and gilt bronze. Italian, *c*1500. Worshipful Company of Cutlers, London, 1979-96a

25. Two-pronged fork. Gilt steel. Italian, *c*1550. Worshipful Company of Cutlers, London, 1979-98

26. Goblet. Enamelled glass and gilt. Venice, *c*1480. V&A: 7536–1861

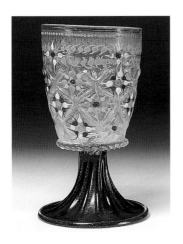

ually, the *credenza* developed into a decorative object that was laid out for special events with tiers of all the household's finest plate and silverware (plate 23). In the fifteenth century, Florentine families occasionally borrowed dishes from acquaintances in order to make a more striking display at wedding celebrations.

Many different types of tableware developed during this period. Until the early Renaissance it was customary to eat off wooden platters or trenchers, which were often shared by at least two people. Wine and water were drunk out of pewter vessels, or silver ones for special occasions, and food was lifted to the mouth with knives, bread or fingers. It was during the course of the fifteenth century that more specialized dining utensils were adopted, made of precious as well as non-precious materials, some of them intended as much for display as for practical use. The rituals of dining became more involved, with a growing emphasis on correct etiquette as a mark of civility and refinement. As a result, plates were often provided for personal use and cutlery played a more important role (plate 24). Spoons and forks began to appear on the dining table. Originally equipped with only two prongs, forks served mainly to secure food while carving or for eating sweetmeats (plate 25). They became more widespread in Italy, and particularly Venice, earlier than in many other countries, but until the seventeenth century they still remained the preserve of the wealthy.

Although silver plates and serving dishes had far greater financial value, glass and ceramics were also proudly displayed on the

tables of well-to-do households. Most Italian glass was made on the Venetian island of Murano, where trade secrets were very carefully guarded, highlighting the sense that it was an innovative product. Of course, glass manufacture had a very long history that dated back to classical times and this was another key to its popularity, given that Renaissance Italians appreciated anything that linked them with their Roman ancestors. However, the fact that Renaissance glass was lighter and more transparent than ever before, a testimony to the skills of modern artisans, was a source of particular delight. Glass production evolved swiftly with the perfection of new techniques. In the fifteenth century, goblets and beakers were often gilded or decorated with enamels, adding to their intrinsic worth (plate 26). Subsequently, the focus shifted to the form of the objects, sometimes in order to create breathtakingly fragile pieces that were designed purely for decorative purposes (plate 27).

Tin-glazed earthenware, or *maiolica*, also responded to the demand for new and intriguing products for the home. Wealthy families commissioned complete dining sets of *maiolica*, sometimes numbering as many as a hundred pieces. Alongside the usual plates and bowls, these sets could also include large-scale pieces such as wine coolers, fruit bowls or ewers and basins, whose forms sometimes imitated more expensive goldsmiths' work. The term *maiolica* was originally used by Italians to describe imported Spanish pottery, made in Valencia. It was characteristically decorated with designs of intertwining vine leaves and tendrils, like this pair of vases showing the arms of the Florentine Gondi family (plate 28). The metallic sheen was achieved through the application of metal oxides during a third round of firing in the kiln.

During the course of the fifteenth century, various *maiolica* production centres were established in different areas of Italy. They all had their own distinctive style and refined their techniques in order to produce more delicate forms, decorated with a broader colour palette. Some *maiolica* goods were painted with narrative scenes, taken from historical or literary sources, whose compositions were often adapted from engravings by famous artists. These

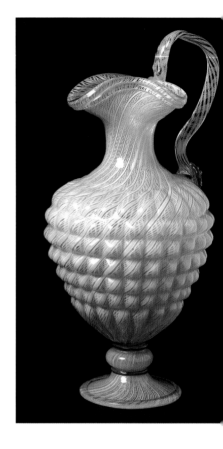

27. Ewer.
Filigree glass *a retorti*. Venice, 1550–1600. British Museum, London, MLA 1869-6-25-45

28. Two jars decorated with the arms of the Gondi family of Florence. Tin-glazed earthenware. Southern Spain, Valencian region, late 15th century. British Museum, London, MLA G 552-3, 554-5

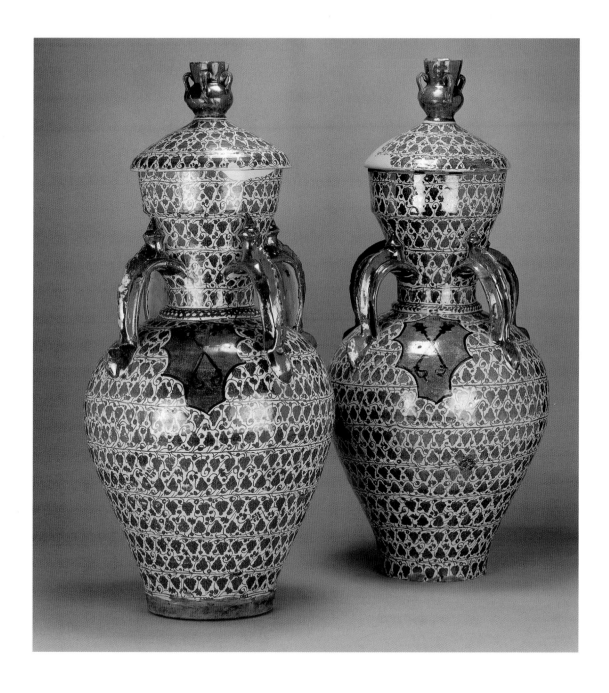

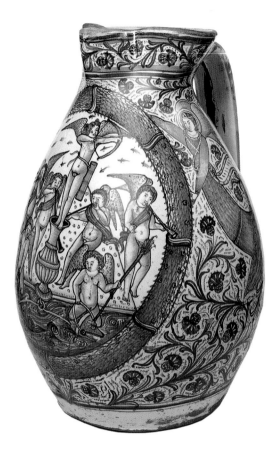

pieces succeeded in matching technical know-how with artistic excellence, and many potters became well known, even signing and dating their work. Many variations of Italian *maiolica* were predominantly blue and white, reflecting the strong influence of Eastern ceramics. Chinese porcelain, for instance, was much coveted, not least because Italian artisans ultimately failed in their attempts to reproduce it. This jug combines a popular European subject, the *Triumph of Cupid*, with a surrounding design of carnations that demonstrates a familiarity with blue and white Iznik pottery from Turkey (plate 29). During the second half of the sixteenth century, a further type of *maiolica* was perfected in the town of Faenza, characterized by a thick white glaze that softened the contours of plates, vases and other objects, like this eggcup (plate 30).

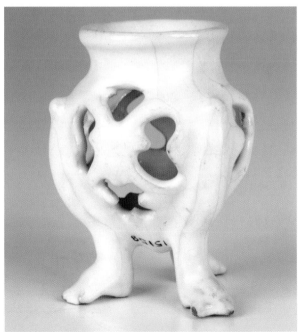

29. *Triumph of Cupid* jug.
Tin-glazed earthenware.
Faenza, *c*1480.
V&A: 1586–1855

30. Tripod eggcup.
Tin-glazed earthenware.
Faenza, *c*1550–1600. Museo
Internazionale delle Ceramiche,
Faenza, 15158

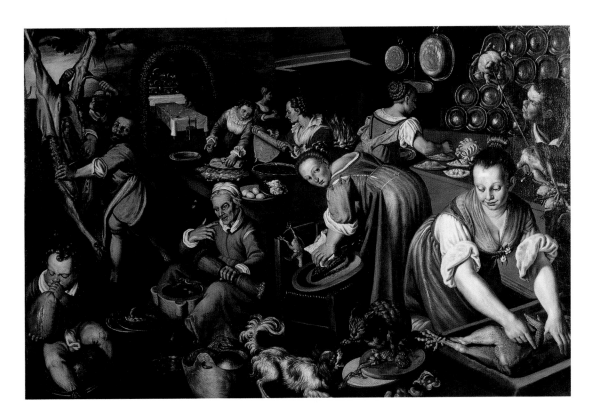

31. Vincenzo Campi,
Cucina (Kitchen Scene).
Oil on canvas. Cremona, 1580s.
Pinacoteca di Brera, Milan

The food and drink served in these objects would have been prepared in a kitchen that was usually located within easy reach of the *sala*. Before the fifteenth century, the kitchen had traditionally been situated on the top floor of a house so that wood smoke could escape easily through chimneys straight under the roof and fires posed less of a risk. However, thanks to the development of improved ventilation systems, it was considered preferable to place it closer to the *sala*, in order to shorten the journey from cooking hearth to dining table. This is the arrangement shown in a painting by Vincenzo Campi, where a meal is prepared in a bustling kitchen while next door a servant lays tables for a festive occasion (plate 31). Sometimes the kitchen also led onto a small service staircase, making it simpler to carry food directly to rooms on

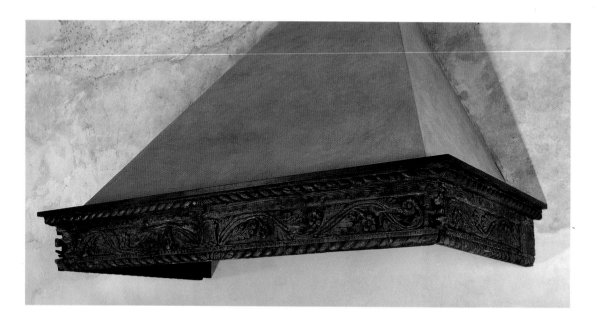

other floors or to collect provisions that were kept in a cold store on the ground floor. For many less wealthy individuals, the kitchen was the nucleus of the home because it was well heated and also served as the main dining area. For patrician families, on the other hand, it was the domain of the mistress of the house and her servants, and was often intentionally kept out of the sight of male relatives and visitors. Instead, it provided a backdrop for the mix of different social groups that passed through the household or lived in it temporarily. These included a whole host of local tradesmen and servants – and sometimes slaves from Eastern Europe as well as Africa.

Even though the kitchen was not one of the most elegant domestic spaces, it was certainly among the most useful. Its central feature was the fireplace (plate 32). Once a basic chimney hood placed over a fire burning on the floor itself, over the course of this period new designs appeared for more sophisticated, built-in fireplaces, in order to make

32. Fireplace hood.
Carved larch wood.
Treviso area, *c*1540.
Ca' da' Noal, Treviso, M.451

33. Storage jars.
Earthenware. Florence, *c*1520–50.
Palazzo Vecchio, Florence

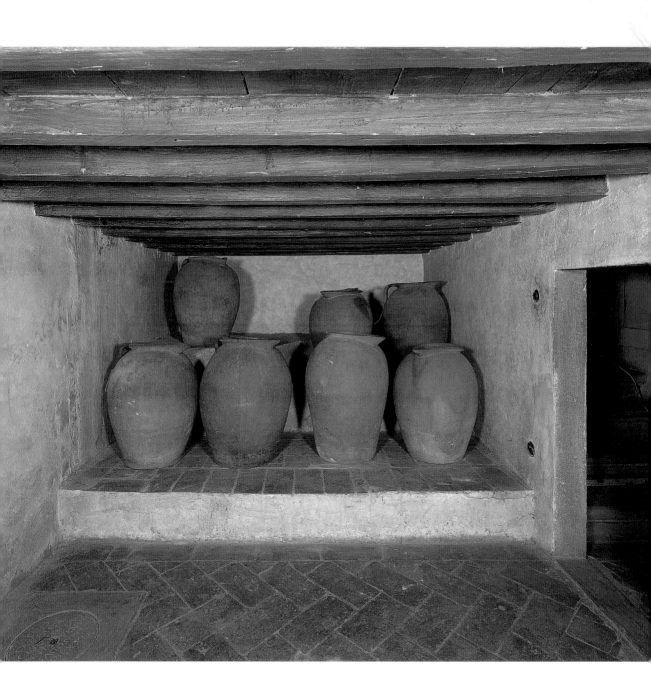

cooking easier and safer. In the late sixteenth century, kitchen fires were sometimes lit on a raised stone surface, increasing their efficiency and making it possible to heat various pans simultaneously. The main daily meal often included types of red meat, which were either boiled in pots made of copper or soapstone, or roasted on a spit directly over the fire. Poultry, such as capons, partridges and even peacocks, was usually reserved for more special occasions, following the custom that food offered at a meal should be appropriate to the social standing of the guests. In the sixteenth century, vegetables, including salads, became common fare even for wealthy Italians, sometimes to the surprise of visitors from abroad. At the same time, meals for important events, such as weddings, grew increasingly elaborate, including larger numbers of courses, each one comprising several dishes.

Well-off families possessed substantial supplies of dry and preserved foodstuffs, which were mainly kept elsewhere in the home. Although small amounts of flour, oil, vinegar and so on would have also been stored in the kitchen, this room was used above all for cooking. On the whole, it contained few pieces of furniture, apart from trestle tables that provided surfaces for activities such as chopping meat and rolling out pasta. In contrast, however, it housed a great range of functional objects, such as bellows, tripods, sieves, bowls and basins, many of which survive today only as archaeological finds (plates 33 and 34). Large pestles and mortars were used to grind and mix a wide variety of ingredients. A treatise on cookery, printed in Venice in 1570 and written by Bartolomeo Scappi, the head of the Vatican kitchens under Pope Paul III, demonstrates just how specialized these culinary tools could be in the best-equipped residences (plate 35).

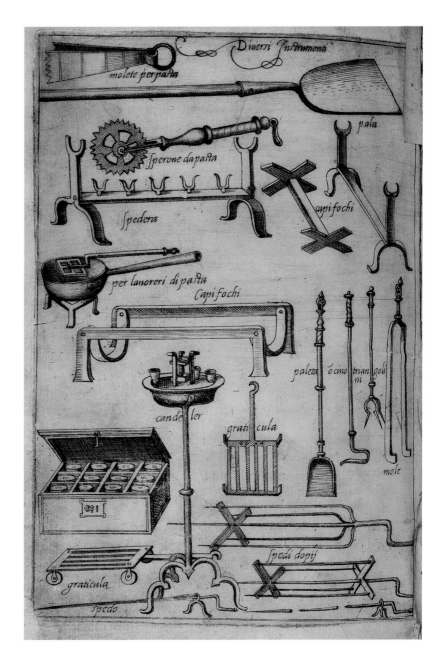

34. Jug.
Earthenware, incised,
green glaze.
North Italy, probably
Bologna, *c* 1510–20.
V&A: 1187–1901

35. Bartolomeo Scappi,
*Tools for the Kitchen and the
Fireplace* from 'Opera'.
Venice, 1570.
Bodleian Library, Oxford

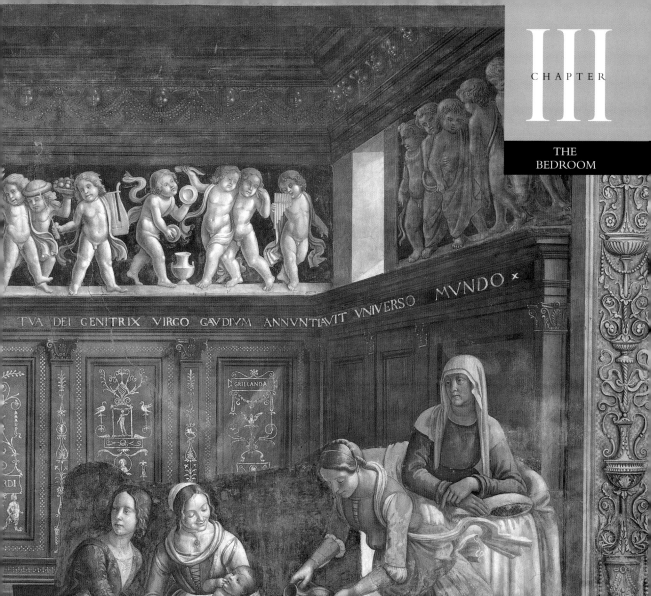

TVA DEI GENITRIX VIRGO GAVDIVM ANNVNTIAVIT VNIVERSO MVNDO ×

GRILLANDA

THE BEDROOM:
Marriages, Births and Everyday Life

COMPARED WITH THE *sala*, the bedroom, or *camera*, was more densely and lavishly furnished. It was sometimes used to entertain friends and important guests, or even to discuss business matters, and consequently was a much more public space than most bedrooms are today. Although there are no surviving examples of the most common type of bed, the *lettiera*, it appears in many paintings from the period. In most cases, it was a monumental piece of furniture that dominated the room. Its scale is conveyed in this panel painting by Lorenzo di Pietro, showing three sisters, who received a gift of dowry money from St Nicholas, all tucked up side by side in a single bed (plate 37). The bed was normally raised high off the ground so that the host, reclining in comfort propped up against cushions, had a perfect vantage point to survey his or her visitors (plate 38). Alternatively,

PREVIOUS PAGES:
36. Domenico Ghirlandaio, *Birth of the Virgin*. Fresco. 1486–90. Tornabuoni Chapel, Santa Maria Novella, Florence

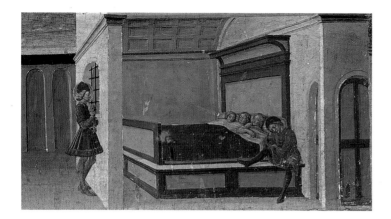

37. Lorenzo di Pietro (Vecchietta), *St Nicholas Giving Dowry Money to Three Poor Girls*. Tempera on panel. Siena, *c*1476. Museo Diocesiano, Pienza

38. Antonio del Pollaiuolo (designed by), *The Nativity of St John the Baptist*. Embroidery in coloured silks and metal threads. Florence, *c*1466–87. Museo dell'Opera del Duomo, Florence

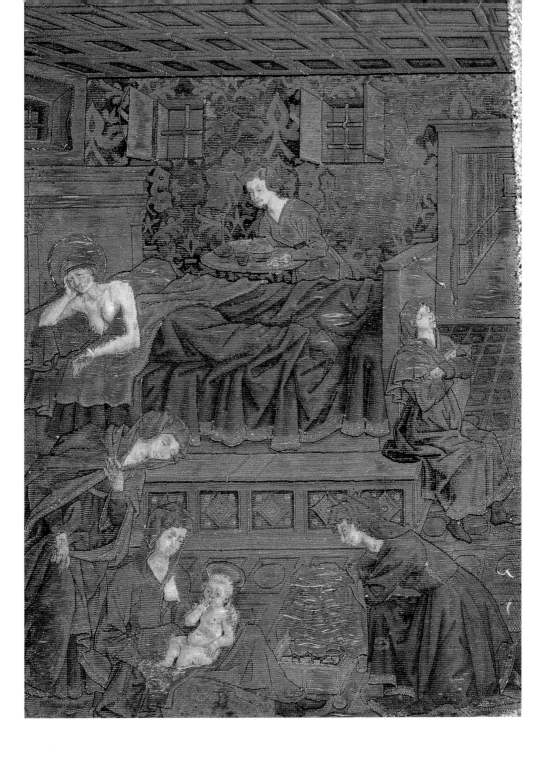

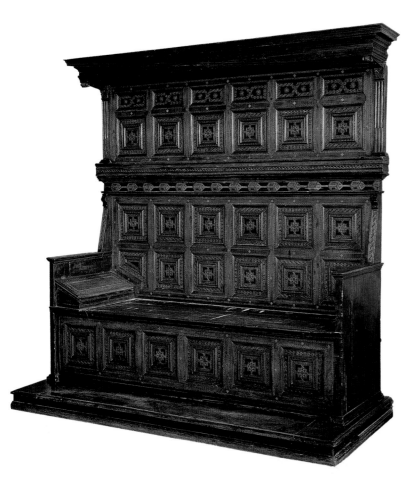

39. *Lettuccio*.
Poplar and walnut frame, walnut
intarsia and veneer, stained oak,
silo and other regional woods.
Siena, 1450–75.
Palazzo Pubblico, Siena
(Monte dei Paschi)

40. Valance.
Silk velvet with padded appliqué
of silver tissue embroidered in
coloured silks and couched metal
thread. Italy, 16th century.
V&A: 37–1903

curtains, which were often suspended from an overhead canopy, could be drawn around the bed for warmth and greater privacy. In the fifteenth century, beds were sometimes built into the wall and surrounded by chests, which could be used as seating. During the course of the sixteenth century, this arrangement fell from use and was replaced by freestanding beds with legs. In addition to the marital bed, Tuscan bedrooms could also include a day bed, or *lettuccio* (plate 39). The day bed was, in a sense, a forerunner of the modern chaise longue or sofa. Contemporary representations show figures reclining sideways across them, resting against pillows placed at either end. At the back of the day bed was a high headboard, sometimes equipped with pegs for hanging hats and other objects.

Some of the most valuable furnishings in the whole house were kept in the bedroom. They included textile wall hangings, as well as the valances, curtains and embroidered silk canopies that decorated

41. Chest.
Walnut and rosewood inlaid with ivory. Venice, *c*1500.
V&A: 7223–1860

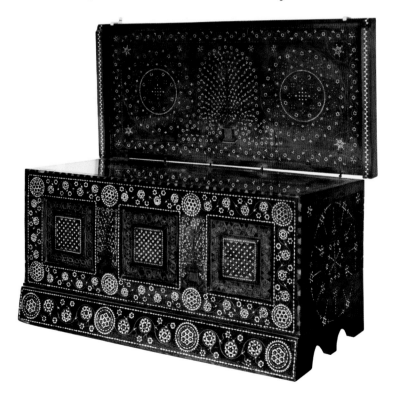

these imposing beds (plate 40). Bedrooms also contained wooden chests, or *cassoni*, in order to store the ever-multiplying quantities of domestic goods, such as bedding, linens and sometimes books. At the beginning of the fifteenth century, chests were still relatively basic objects, necessarily so because they were also used to transport belongings. In Florence they were often painted with narrative scenes, while in Venice a form of inlay work with geometric motifs was popular (plate 41). Later, in the sixteenth century, they became more static pieces of furniture and as result took on highly elaborate and sculptural forms. It became increasingly common to decorate the entire bedroom as a unified whole and the walls could be covered with a series of painted wooden panels that matched the bed and its headboard. The desired overall effect was one of richness, the muted tones of the wood contrasting with brightly coloured fab-

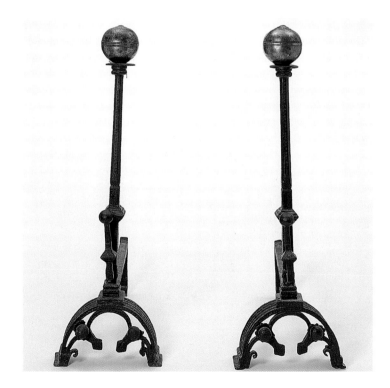

42. Firedogs.
Wrought iron, brass.
Italy, 16th century.
V&A: 56,56A–1905

rics. Since many of these textiles have faded over time, it is easy to forget that interiors were originally furnished in crimson, sky-blue, golden yellow and deep green.

The most luxurious Venetian bedrooms radiated luminosity and warmth. Visitors described a *camera d'oro*, or 'golden chamber', where the spectacular natural light that reflected off the waters of the lagoon was enhanced by a large open fire and locally produced glass objects sparkled in the glow of the flames. The fireplace occupied a prominent position in the Venetian bedroom and was usually surrounded by functional as well as highly ornamental objects, such as bronze firedogs and bellows (plate 42). Gilded leather hangings on the walls and gilded wooden ceilings and chests crowned the effect of a room suffused with light.

The bedroom was the setting for many important family events. Although some treatises recommended that husbands and wives should have separate bedrooms, practically this was not always possible and it was essentially a space the couple shared. It was often furnished to mark the occasion of a marriage and

43. Wedding chest.
Gilded and carved walnut, decorated with *pastiglia* and tempera. Verona, *c*1490.
Museo Poldi Pezzoli, Milan

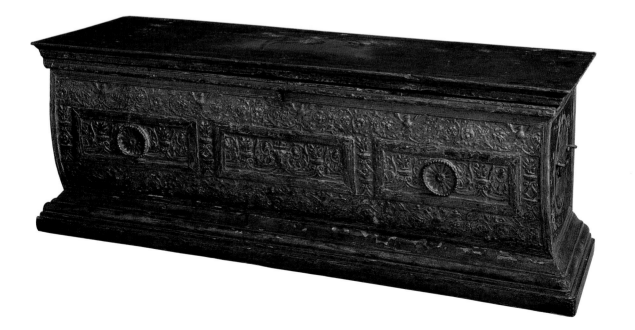

contained objects incorporating messages intended to educate and inspire the bride as well as to promote fertility, such as painted chests given as wedding presents. This chest, illustrating the story of the ancient Roman naval hero Duilius and his wife Bilia, who was a model of patience and chastity within marriage, was designed to set an example for the newly wed couple (plate 43). Many marriage chests also proudly displayed the conjoined arms

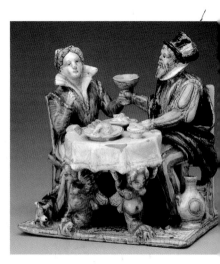

44. Couple dining at a table. Tin-glazed earthenware. Urbino, 1550–1600. Museo Civico, Pesaro, 4363

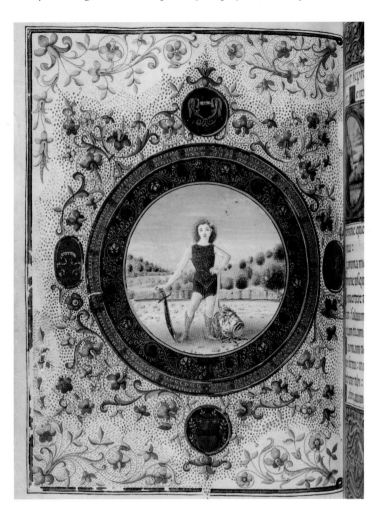

45. Monte di Giovanni and Mariano del Buono (illuminations by), Book of Hours for the Serristori family. Parchment. Written in Florence, c1500. V&A: NAL, MSL/1921/1722

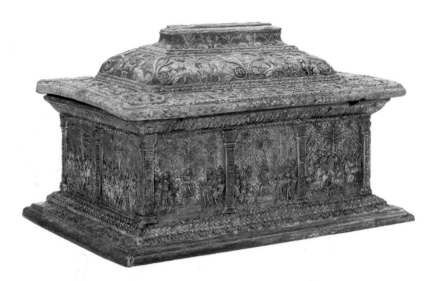

46. Casket. Softwood (probably poplar) with *pastiglia* decoration and water-gilding. Italy (Ferrara or Venice), 1500–50. V&A: W.23–1953

47. Engagement ring. Diamond set in gold with enamelling. Northern Italy, 15th century. British Museum, London, MLA AF 1090

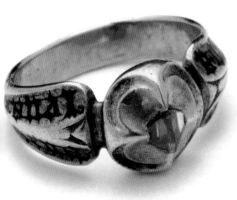

of the families of the bride and groom. This custom was a reminder that, far from being simply the union of the couple, as symbolized in this vivid *maiolica* scene of two figures drinking from the same cup (plate 44), a wedding was the start of a profound link between the interests and social standing of two extended families and their households.

A young girl, marrying for the first time, left behind not only her family but also the house in which she had grown up. Rather than setting up on their own, the couple generally lived in the home of the parents of the groom. Most of the furniture in the bride's new bedroom would have been chosen and purchased by her husband-to-be with the assistance of his family. In the fifteenth century, the marriage trousseaux of wealthy girls sometimes included furniture, but this became increasingly rare. Later, the trousseau mainly contained small, moveable goods and objects connected with the bride's toilette and clothing. These items were her legal possessions and women frequently chose to bequeath them to their female descendants, so that they were passed down from one generation to the next. Trousseaux inventories often list paintings, sometimes of a devotional nature, books (plate 45), sewing equipment, such as thimbles and spindles, and other small,

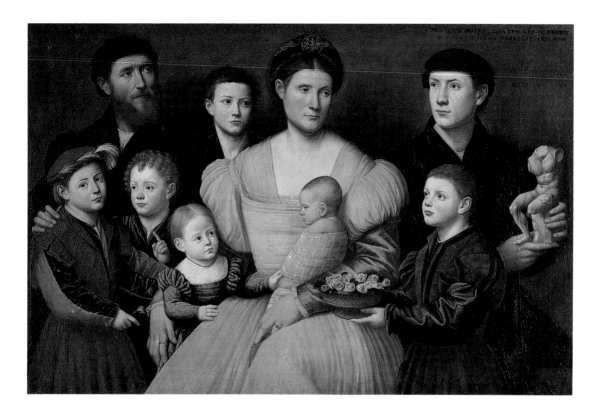

48. Bernardino Licinio,
*Portrait of Arrigo Licinio and his
Family.* Venice, c1535.
Galleria Borghese, Rome

decorative items, including globes or ornamental boxes for storing jewellery. Sometimes these boxes were scented with musk and showed detailed narrative scenes taken from classical histories or mythology, modelled in a type of white lead known as *pastiglia* (plate 46). As a counterpart to the dowry provided by the bride's family, the husband presented his wife-to-be with various presents, including her wedding ring, dress and accessories (plate 47). Marriage negotiations between patrician families could take a long time and this exchange of gifts during the period of betrothal symbolized the consent and goodwill of the parties involved.

Women were often transitory members of the household. When a husband died, he had the power to decide in his will whether his wife could continue to live in her marital home. If

49. Jacopo Pontormo,
Naming of St John the Baptist.
Tempera on panel. Florence,
*c*1525. Uffizi, Florence,
Inv. 1890, n.1532

not, she had the choice of returning to her father's house, entering a convent or eventually remarrying. At all social levels, a vital way of establishing her position was to produce several heirs (plate 48). Various objects were thought to encourage pregnancy, such as special stones and furs, placed on or worn around the stomach. The little naked boys, called *putti*, or figures of a naked man and woman painted on the inside of many marriage chests were also considered to be auspicious symbols. Once pregnant, women were encouraged to contemplate beautiful images, which were often present in the bedroom, such as depictions of the *Virgin and Child*, in order to have a healthy, well-formed baby.

After the birth, visitors were received in the bedroom to congratulate the parents. Many paintings and frescoes contain scenes showing the mother surrounded by friends and servants, who wash and care for the infant. As in Domenico Ghirlandaio's fresco showing the *Birth of the Virgin*, women were most prominent in these compositions (plate 36). In some cities the law decreed that only female friends and family members could attend these domestic celebrations, which were closely controlled, especially regarding the food that could be offered. It was feared that extravagant displays of wealth could incite envy, and stir up social problems among people living at such close quarters. Various gifts were presented to the expectant mother during pregnancy and after the birth, including painted birth trays, called *deschi da parto*. These sometimes depicted allegories of love and marriage or religious scenes relating to the event they commemorated, such as this tray by Jacopo Pontormo showing the *Naming of St*

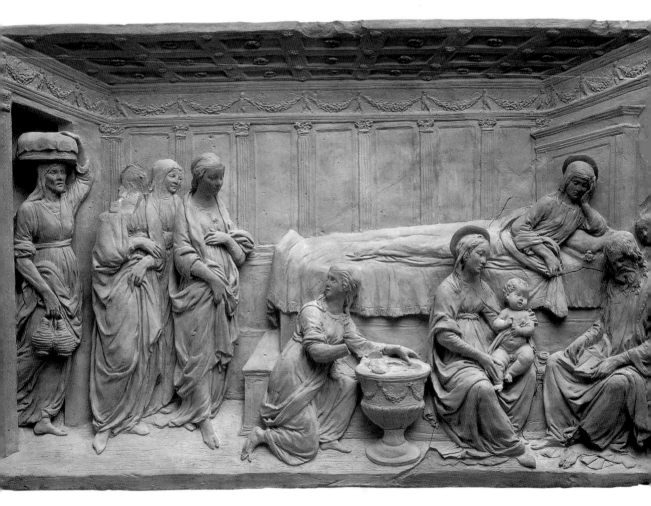

John the Baptist (plate 49). Typically, the families' arms are shown on the reverse of the tray. A relief by Benedetto da Maiano shows how birth trays were brought into the bedroom laden with fruit and other foodstuffs (plate 50). Afterwards, however, they were usually hung on a wall like paintings. Another type of gift was the *maiolica* birth set. In its simplest form it consisted of a bowl with a lid and was designed to carry refreshments, such as warm broth, for the mother (plate 51). Here, the bowl shows two women

50. Benedetto da Maiano, *Birth of St John the Baptist*. Terracotta. Florence, *c*1477. V&A: 7593–1861

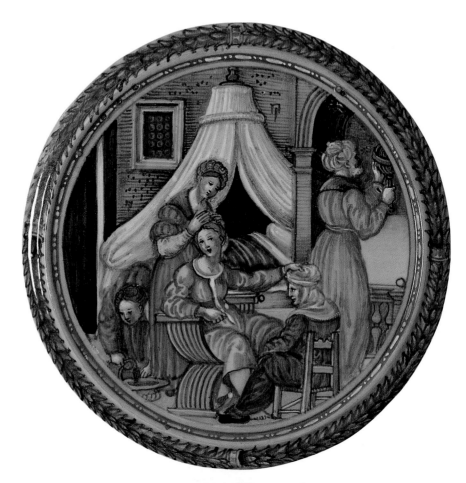

51. Birth set.
Tin-glazed earthenware.
Casteldurante, c1525–30.
V&A: 2258–1910

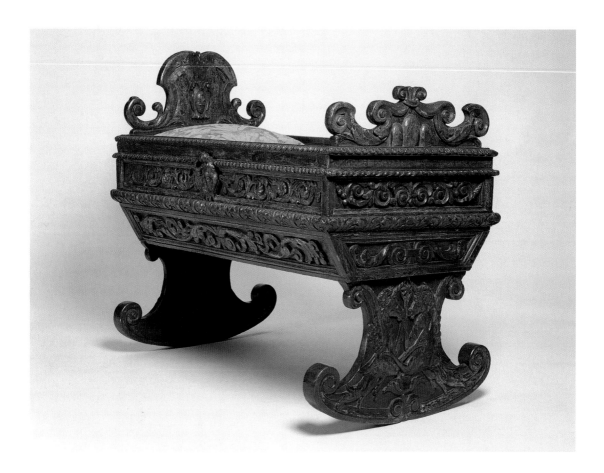

caring for a newborn baby, while the lid depicts a woman being assisted in labour. Standing at the window, an elderly man uses an armillary sphere to calculate the astrological forecast of the imminently expected arrival.

The physical dangers of childbirth and high infant mortality did not stop lengthy and loving preparations beginning months before the baby's arrival. The cradle, sometimes intricately carved like this wooden, rocking one, and its accompanying bedding were naturally some of the most important acquisitions (plate 52). A range of objects was available to safeguard the newborn child.

52. Cradle.
Walnut with gold traces. Italian, 16th century. Philadelphia Museum of Art, 2000-117-1

53. Agnolo Bronzino,
Portrait of Giovanni de' Medici.
Tempera on panel.
Florence, 1545. Uffizi, Florence

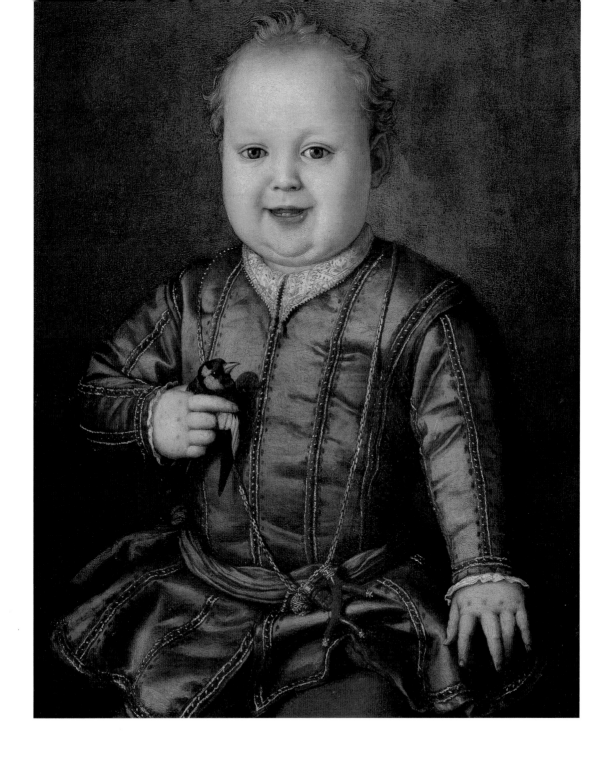

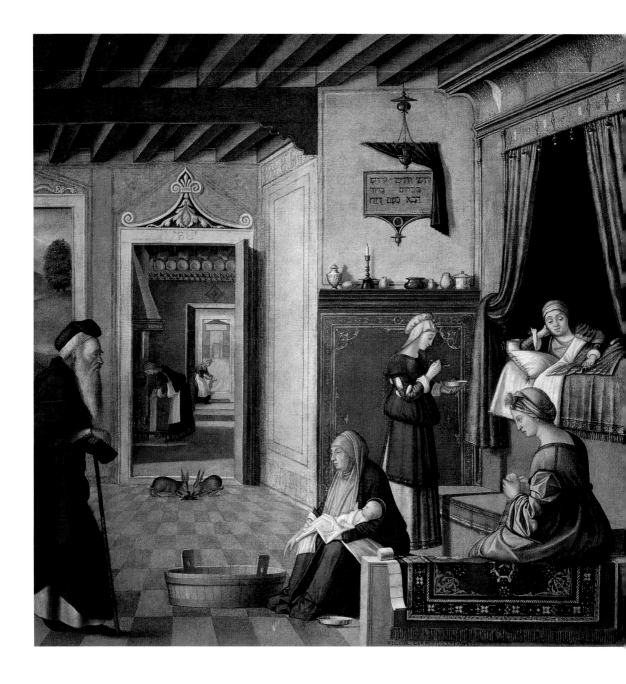

54. Vittore Carpaccio,
Birth of the Virgin.
Oil on canvas. Venice, 1504.
Accademia Carrara, Bergamo, 731

55. After Donatello, painting and
gilding probably by Paolo di
Stefano, also known as Paolo
Schiavo, *Virgin and Child.*
Painted and gilded stucco on
wood. Florence, late 1430s.
V&A: A.45–1926

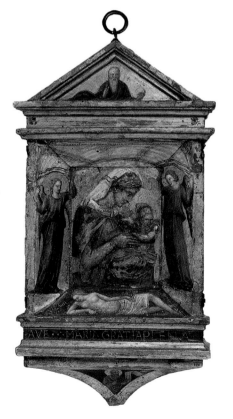

Coral was believed to provide protection against diseases and was often hung around small children's necks on a pendant (plate 53). In this painting of the *Birth of the Virgin* by Vittore Carpaccio (plate 54), the infant has just been bathed in a wooden tub and then wrapped in linen towels, which have been warmed in front of the fire. The servant seated on the parapet in the foreground prepares one roll of swaddling bands, while another can be seen at her side. Children were often massaged with oils and then tightly wrapped in these strips of linen in the belief that it would protect them and also encourage their limbs to grow straight.

As well as these life-changing events, the bedroom was the setting for a variety of daily activities. Far from being confined to public places of worship, religious devotion played a very important role in the home. Sacred images were present in many different areas of the house, in books and paintings as well as prints. Prints were widely used, even in wealthy households, often because they presented an opportunity to own copies of much-admired religious works of art, such as Michelangelo's frescoes from the Sistine Chapel in Rome. Most bedrooms were hung with at least one representation of the *Virgin and Child*, like this small relief after Donatello (plate 55). Family members who used the room cultivated an active relationship with these images of holy figures, who were thought to bless the house and watch over its inhabitants. Some paintings were kept draped under a curtain and were revealed only for moments of private contemplation and prayer. Candles were sometimes lit in front of them and they were sprinkled with holy water. The recital of the rosary, a series of prayers and meditations often repeated several times a day, was one of the most common forms of devotion. Then, as today, a chain of beads of varying sizes was used in order to keep track of their number and sequence. Originally simple knotted ropes, rosary beads became increasingly ornamental objects and, in some cases, even a fashion accessory: many sixteenth-century portraits show women wearing them loosely fastened around their waists. They were made of a variety of valuable materials, such as semi-precious stones, silver and gold, or rock crystal (plate 56).

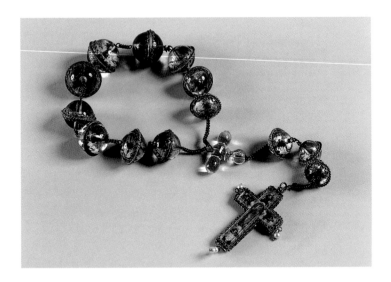

56. Rosary.
Rock crystal beads and cross, with painted and gilded images, silver-gilt mounts, decorated with pearls. Italy, 16th century.
Museo Civico, Turin, inv. 105/VD

The care of the body was another time-consuming ritual. Personal hygiene and the pursuit of beauty were serious matters, even though some of the methods used to achieve cleanliness were very different from those employed today. Domestic bathrooms were extremely rare in Italy throughout this period. In Genoa, one of the few cities where they were adopted, during the second half of the sixteenth century bathrooms were usually small, highly decorated spaces, equipped with in-built steam pipes and baths that could hold up to ten people. They seem to have been designed to offer a social experience as much as a utilitarian one and were perhaps commissioned by Genoese merchants who had become acquainted with Turkish baths while on their travels abroad. In most other cases, however, it is likely that more modest forms of bathing took place in the bedroom. It was unusual to wash the whole body frequently with water, partly because it was believed that water could penetrate the skin and have a contaminating effect, perhaps even causing exposure to diseases. Instead, white linen towels moistened with perfume were used to rub off dirt and sweat, and water was restricted to the washing of hands and faces. Odours were disguised with scents, which were also thought to

purify the air. It was customary to add musk and other essences to dress accessories, particularly gloves. Women carried or wore pomanders, small spheres made of gold or silver-gilt, which, when opened up, could be filled with perfumes (plate 57). Rooms were also scented with perfume burners, like this bronze example, crowned with the figure of Pan. Originally partially gilded, when it was lit it would have been a striking sight, with smoke billowing out from the mouths of the mythological creatures depicted around its sides (plate 58). By the sixteenth century, white linen undershirts, intentionally worn so that they were visible at the collar and cuffs, were generally regarded as a sign of the wearer's cleanliness and civility. Most wealthy men and women owned at least 20 or 30 long undershirts, many of them finely decorated with lace or embroidery (plate 59). They soaked up dirt and removed it from the body, while at the same time protecting the costly

57. Pomander.
Nielloed silver and silver-gilt.
Italy, 14th century.
V&A: M.205–1925

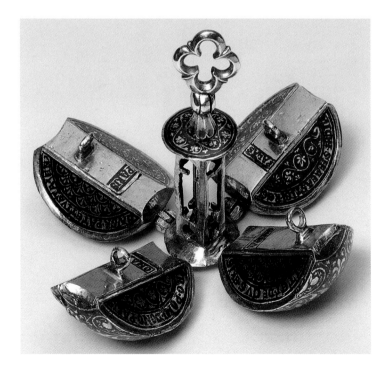

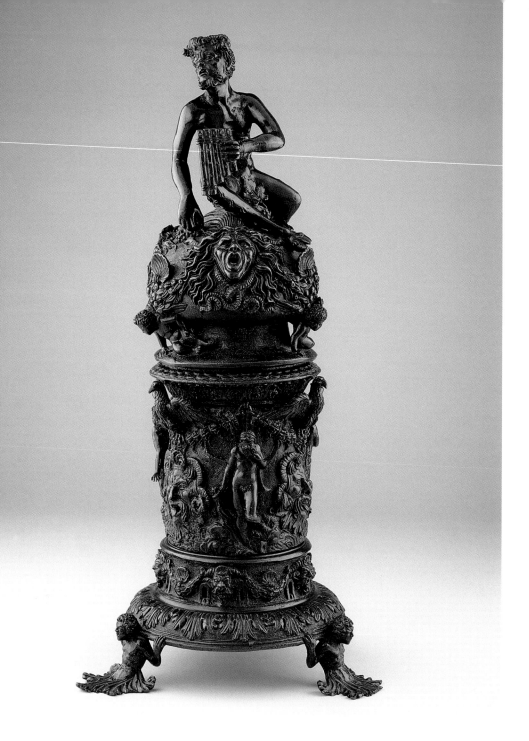

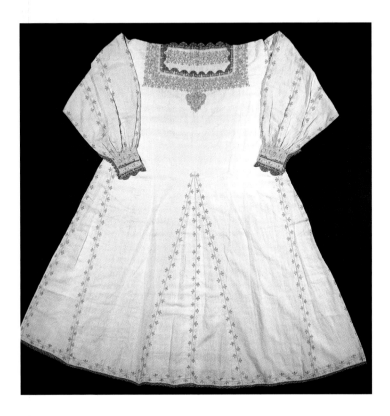

58. Attributed to Desiderio da
Firenze, Perfume burner.
Bronze. Padua, *c*1540–50.
Ashmolean Museum,
Oxford, WA 2004.1

59. Woman's shirt.
Linen embroidered with silk.
Italian, *c*1575–1600. Museo del
Tessuto, Prato, 76.1.16

garments worn over them. Numerous small objects, including combs, tweezers and shaving equipment, testify to the importance of following the latest fashions in hair and make-up (plate 60).

Some embroidered undershirts would have been produced in the home, and inventories often list different types of equipment used for sewing, spinning and the subsequent care of finished items. Books about household management underlined how important it was for a wife to be able to sew as well as to oversee the production of bed and table linens. Households contained vast quantities of sheets, towels, tablecloths and napkins. These functional items were often made by female servants. Fine needlework, on the other hand, was the noblewoman's recommended leisure pastime. It was a common view, shared by many male

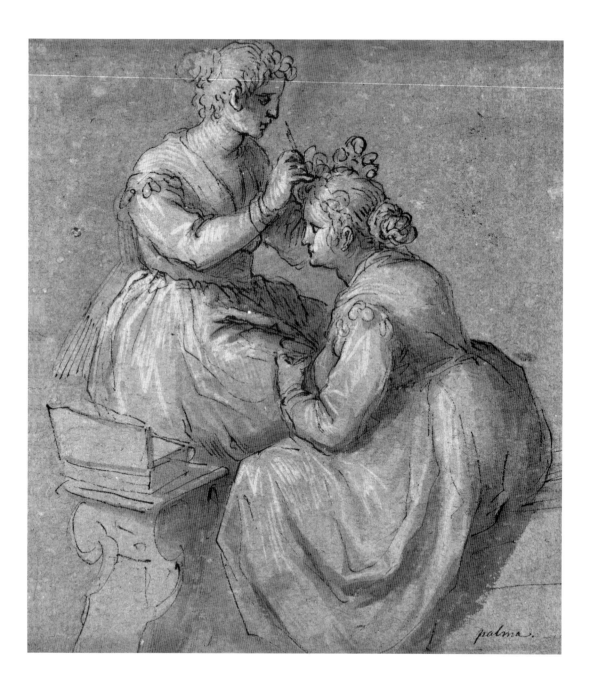

60. Palma il Giovane,
*Two seated women, one
dressing the hair of the other.*
Pen and brown ink, brown
wash and black chalk on
brown paper. Venice,
late 16th century. Pierpont
Morgan Library, New York

61. Cover.
Linen embroidered in
coloured silks. Italian,
16th century.
V&A: T.307–1920

authors, that women were less likely to be a source of trouble to
their husbands if their hands and minds were occupied with inno-
cent pursuits such as embroidery. Designs for projects, such as this
silk cover (plate 61), could be adapted easily in the home from
books containing patterns for lace and embroidery. Increasing
numbers of these pattern books were printed in the second half of
the sixteenth century, mainly in Venice, a city famed for both its
lace production and book trade.

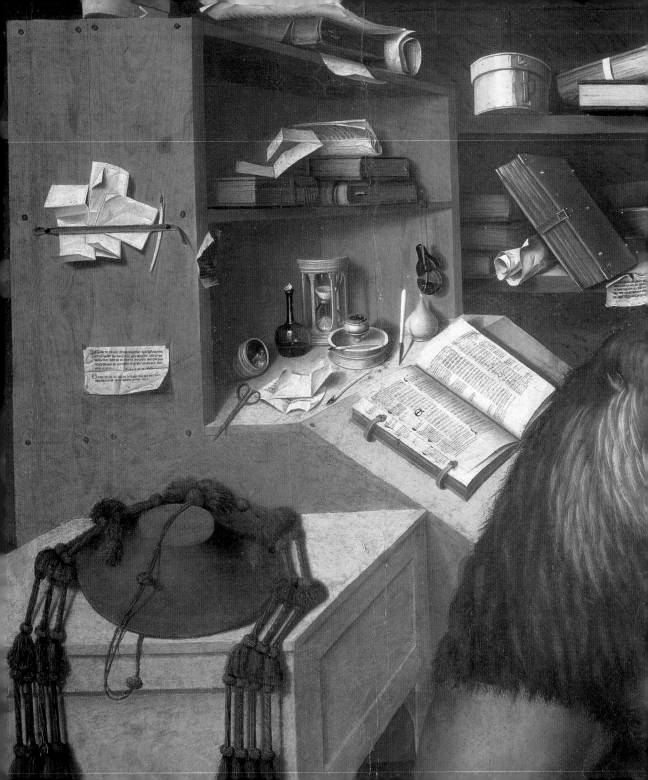

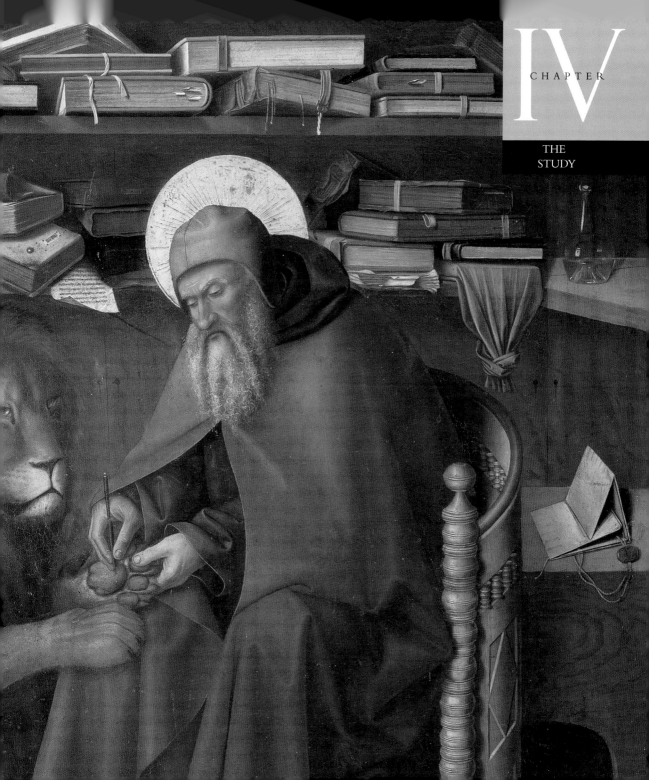

THE STUDY:
Business and Pleasure

T HE IDEA OF A ROOM SET ASIDE specifically for reading, writing and other intellectual pursuits was not by any means a new one. However, it was during the Renaissance that the study, or *studiolo*, began to occupy an important place in the home. The origins of the study can be traced back to the tradition of the scholarly monk in his cell, one of the reasons why so many paintings depict religious men, particularly Sts Jerome and Augustine, in this type of environment. In the early Renaissance only great palaces were equipped with studies, but gradually other social groups chose to incorporate them as part of their houses. What had begun as a solitary, hermit-like space developed into a more sociable room, an office for work and even, in a few cases, a tourist attraction.

Some studies became famous throughout Italy and were visited by artists and scholars as well as more powerful individuals. Piero and Lorenzo de' Medici's *studiolo* in the Medici Palace in Florence was a striking example of this phenomenon, admired by many for its architectural brilliance as well as the unique collection of objects that it housed. Compared with other areas of the Medici Palace, the study occupied a relatively small space and entering it must have felt like stepping inside a treasure chest. The floor and ceiling were both brightly decorated with glazed terracottas by Luca della Robbia. Unlike the floor tiles, the 12 roundels from the ceiling survive (plates 63 and 64). The series illustrates the *Labours of the Months*, each one with a border featuring the appropriate

PREVIOUS PAGES:
62. Niccolò Colantonio, *St Jerome and the Lion*, Oil on panel. Naples, *c*1445. Museo Nazionale di Capodimonte, Naples, Inv. Q.20

63. Luca della Robbia, *January* roundel. Tin-glazed terracotta. Florence, *c*1450–56. V&A: 7632–1861

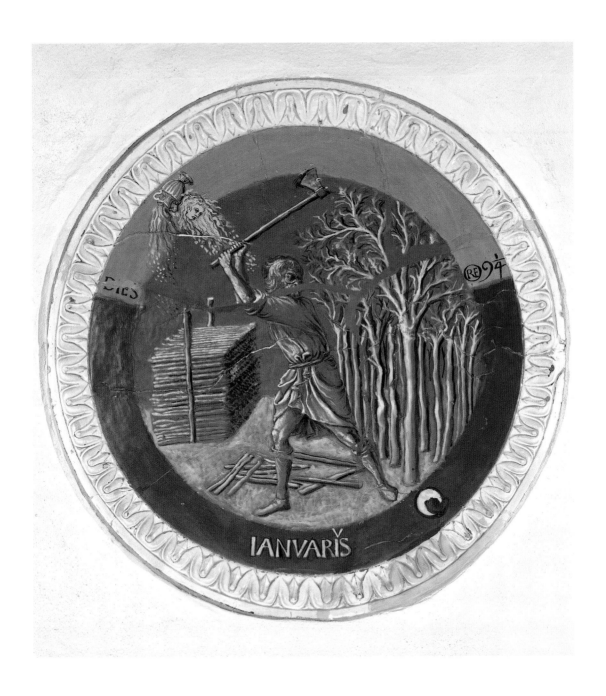

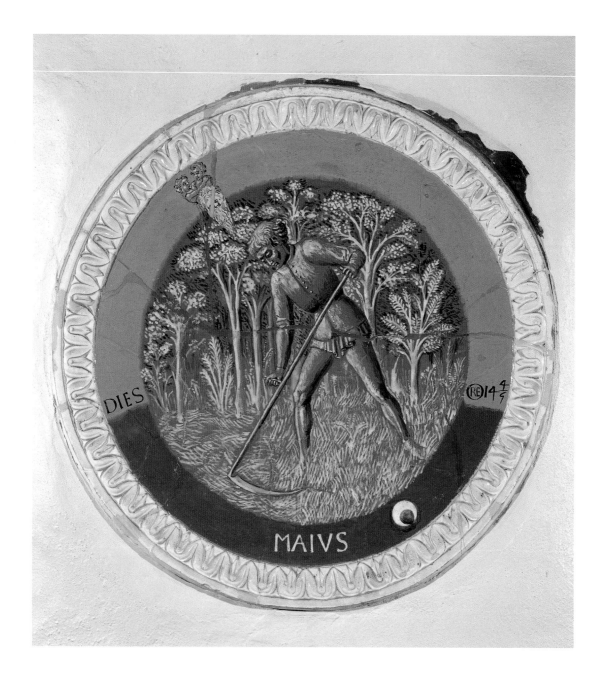

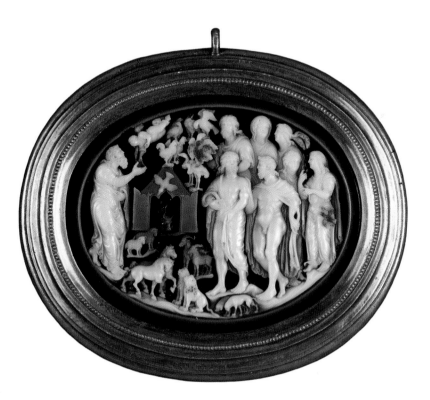

64. Luca della Robbia,
May roundel. Tin-glazed
terracotta. Florence, *c*1450–56.
V&A: 7636–1861

65. Cameo showing Noah and his
family emerging from the Ark.
Onyx and gold. Probably Sicily or
southern Italy, *c*1200–1250. British
Museum, London, MME
1890.9–1.15

sign of the zodiac and phase of the moon, as well as the length of
the day and night. The roundels reinterpreted a theme that had
been popular for centuries, updating it with these details that were
intended to reflect an increasing grasp of science and knowledge
of the natural world. An inventory was made of all the objects
contained in the room after Lorenzo's death in 1492, making it
possible to identify individual pieces of the collection. One of
these was a beautiful onyx cameo set in gold, showing the ark sur-
rounded by Noah, his family and many pairs of animals (plate 65).
Other items in the collection were connected with family history,
such as a medal recording the attempt by the Pazzi family to bring
down the Medici in 1478. Although the plot was unsuccessful, it
nevertheless resulted in the murder of Lorenzo's brother, Giuliano
de' Medici (plate 66).

The Medici study was certainly a very spectacular example of

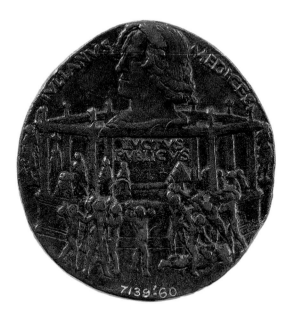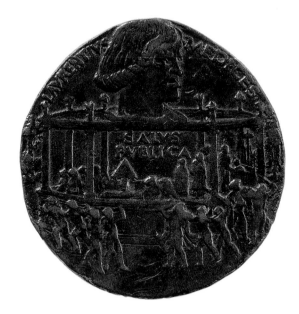

its kind. Most Renaissance studies were far more humble and often had more practical uses. Treatises and books expressed strong views on the location and appearance of the ideal study, often stressing that it should be one of the most private rooms in the house. They suggested that its door should be locked because, in addition to a variety of valuable objects, it also contained important family papers, such as account-books, receipts, contracts and more personal records (plate 67). The legal part of a wedding ceremony was sometimes held here, and the documents signed by the families in the presence of a notary were subsequently preserved in this room. In this sense, the study acted as a storehouse of the family's collective memory. It was also the most 'male' room in the home. Although there is evidence that a few women, especially those who lived alone, had their own studies, such cases were exceptional. Leon Battista Alberti, writing in 1427 about the family and good household management, was very clear in his opinion that these were not suitable places for women. Indeed, he even recommended that husbands ban their wives from ever

66. Bertoldo di Giovanni,
Medal of the Pazzi Conspiracy.
Cast bronze. Florence, 1478.
V&A: 7139–1860

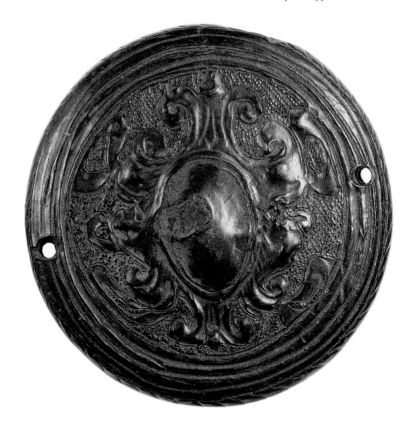

67. Document holder, and detail of top. Wood with cut and embossed leather, with a tinned iron pierced plate. Italy, 1500–50. V&A: 480–1899

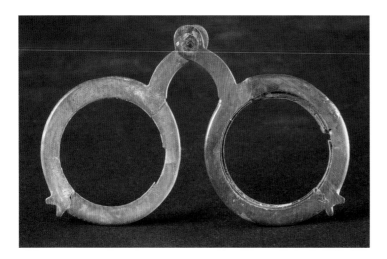

68. Spectacles frame. Horn.
Probably Florence,
end 14th–mid-16th century.
Soprintendenza dei Beni
Archeologici per la Toscana,
Florence, inv.22517468.

entering their studies. Like many of his contemporaries, Alberti was evidently opposed to the idea that women should have increased access to books and knowledge.

Ideally, the study could also be reached without going through other more private rooms in the home. This was because many professional men, such as merchants, notaries and physicians, used their studies for work and needed to be able to receive clients without disrupting the rest of the household. For this reason, in Venice the study was sometimes located on a mezzanine floor, directly underneath the main reception room. The practical nature of the room is reflected by many of the objects that appear in study inventories, such as scales for weighing small objects like coins, scissors and penknives used to cut papers, and eyeglasses (plate 68). Spectacles designed to correct problems of eyesight were already common in Florence and Venice by the fifteenth century and lenses were also used as magnifying glasses to help decipher documents. In addition, studies often contained mirrors because the extra light they created was thought to aid reading. At the beginning of this period they were made of polished steel (plate 69), but by the sixteenth century mirrors were generally made of glass coated with a mercury and tin alloy, a technique that

69. Giovanni Bellini, *Prudence*.
Oil on panel. Venice, c1490.
Gallerie dell'Accademia, Venice

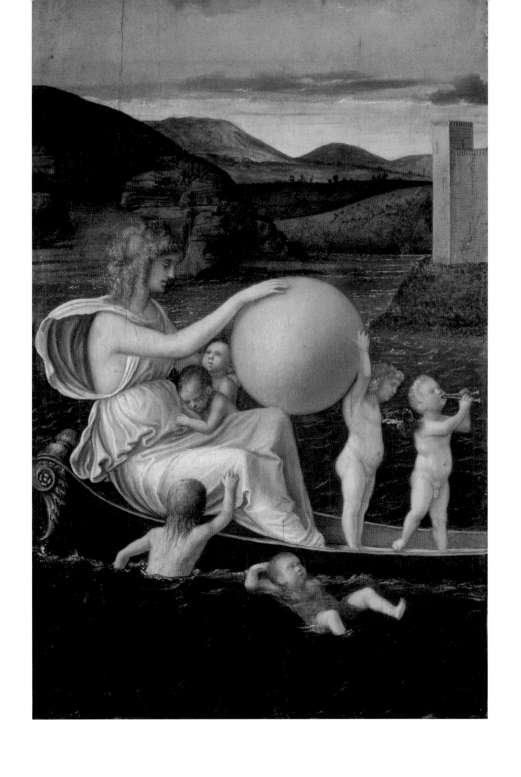

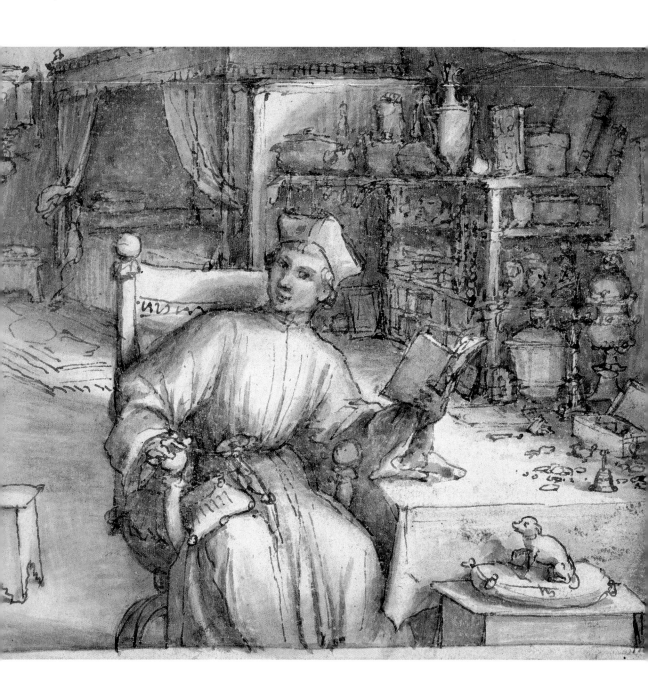

was highly prized because it produced a much clearer reflection.

Even studies used for business could double up as places for quiet contemplation. Architectural plans show that it was not unknown to place the study next to a bedroom, situated towards the back of the house. The evenings presented a perfect opportunity to catch up on work and reading in peace, when the rest of the house was silent, and some studies even contained a bed in case the scholar was momentarily overcome by sleep. This, combined with the cluttered feel of so many belongings amassed together, produced a sense of comfort that, for some, was a vital characteristic of the ideal study (plate 70). For many, the study was a place where an individual could transcend the cares of the bustling household, to relax and cultivate the mind. This aspect is evident in the many records that survive by men who wrote very affectionately about this particular room in the house, describing how much satisfaction they gained from spending time in it.

Fixed furnishings often dictated the overall appearance of the study. Some had wooden-panelled walls and floors made of terracotta tiles, which added a colourful element to the room. In the fifteenth century, a made-to-measure study was often fitted with an imposing wooden structure that combined shelves, a writing table and perhaps a lectern on which to place books (plates 62 and 71). Furniture for the study provided a perfect opportunity to show off the skills of Italian carpenters, who were famed for their intarsia work. An octagonal table inlaid with exotic woods, owned by the Florentine historian Francesco Guicciardini, was probably the creation of woodcarvers who perfected their art by working on large-scale ecclesiastical commissions (plate 72). Freestanding writing desks and cabinets were rare in Italian homes before the second half of the sixteenth century. They developed out of the small boxes with drawers made to keep documents and writing equipment that were used mainly by diplomats and other individuals who needed to travel frequently. This type of portable chest, whose form originated in Moorish Spain, later evolved into the upright cabinet. It was often equipped with a sloping front that provided a writing surface. The arrangement of the drawers

70. Lorenzo Lotto,
Cleric in his Study-Bedchamber.
Pen and ink on paper. Bergamo,
*c*1510–30. British Museum,
London, PD 1951-2-8-34

OVERLEAF:
71. Antonello da Messina, *St Jerome in his Study*. Oil on limewood.
Venice, *c*1475. National Gallery,
London, NG 1418

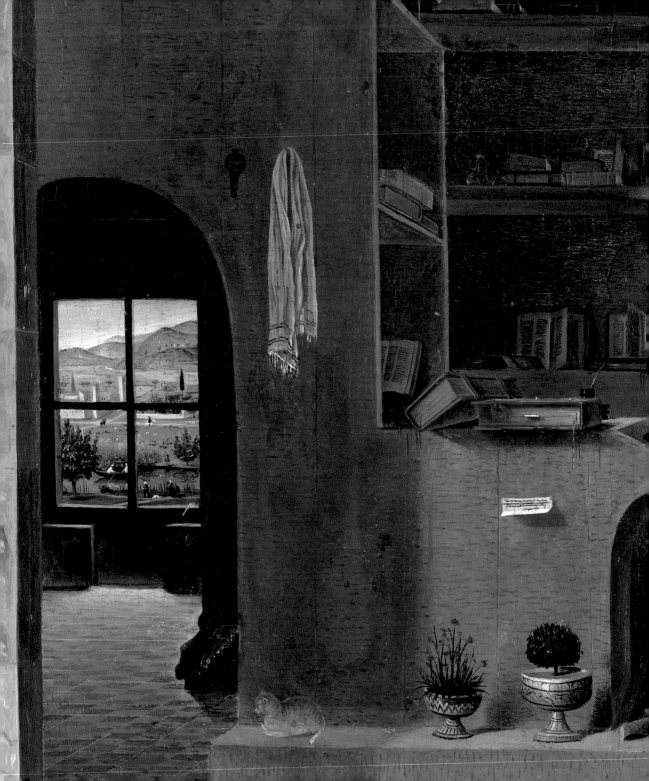

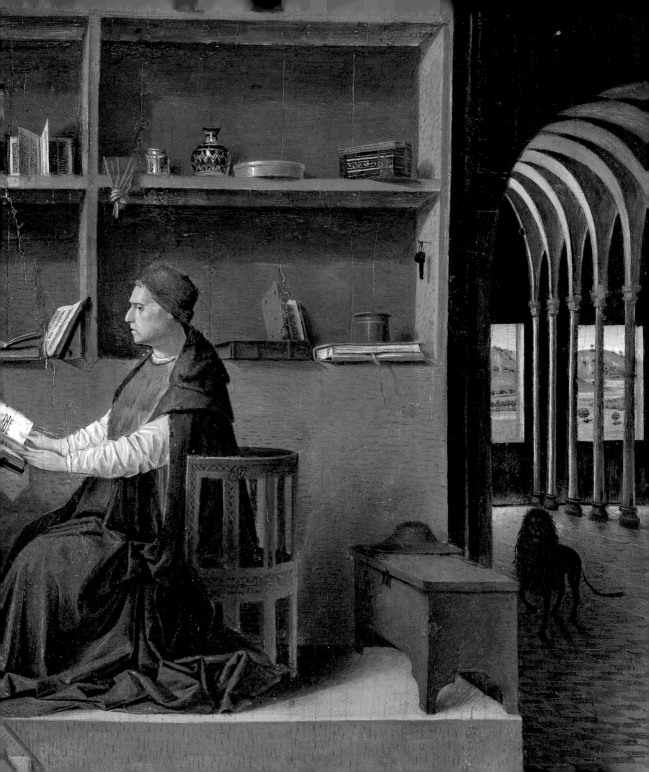

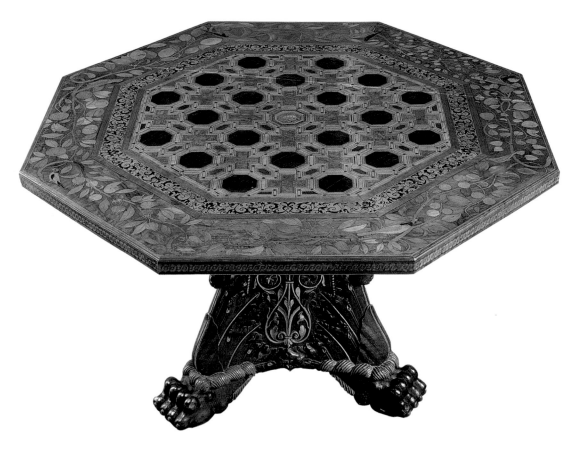

became more and more elaborate and usually contained inge-
niously concealed compartments in order to store precious items.
Towards the end of this period, more ornate cabinets were made
from a large range of valuable materials, such as ebony inlaid with
tortoiseshell, mother-of-pearl and small panels of ivory etched
with allegorical or mythological scenes.

Clearly, no study was complete without books. Some writers
argued that it was more important to have a few well-read volumes
than a large, unused library. Even inventories of small quantities of
books suggest that it was fashionable to cultivate a very broad range
of interests. Cookery books sat next to treatises on medicine and

72. Attributed to Fra Damiano da
Bergamo after a design by Vignola,
Octagonal Table.
Walnut and other woods.
Bologna, early 1530s. Private
collection, Florence

73. F.H. Maripetro, Binding
for *Il Petrarcha spirituale*.
Red morocco, ornament tooled
in gold. Bound in Rome, *c*1550.
V&A: NAL, AM. 93–1866

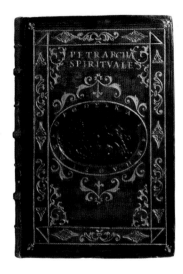

OVERLEAF:
74. Francesco Rosselli, *World Map*.
Hand-coloured engraving. Italy,
*c*1508. National Maritime
Museum, London

recent history books were complemented by classical mythologies. Religious works could be found alongside contemporary love poetry. Although the text, and its authenticity, were obviously of paramount importance, books were also treasured as objects. The layout of many early printed books set out to imitate the format of the beautiful manuscripts that graced the most prestigious libraries. Printed volumes could also be customized, for example with an illuminated frontispiece, perhaps including the owner's name or coat of arms, or a fine, gold-tooled leather binding (plate 73). Some collectors even chose to have their bookbindings colour-coded according to each different subject. The invention of the printing press affected the appearance of studies in other ways. From the late fifteenth century onwards, maps were often hung on study walls, bringing knowledge about new continents into the home. In about 1508, for example, Francesco Rosselli, a Florentine cartographer, engraved the first map of the world to include Christopher Columbus's recent discoveries in the Americas (plate 74).

Some studies were used to house rare and valuable objects, both ancient and modern. In cases like this, a certain snobbery was attached to the room's arrangement. More than any other part of the house, the organization and contents of a collector's study were thought to provide an insight into the mind of their owner. For this reason, it was not enough simply to bring together a variety of beautiful things. Instead, it was essential to understand their true value, to admire them correctly and to be able speak learnedly about them. As a result, decorating a study – and showing off its contents – could be a risky business, particularly given the sophisticated nature of the Renaissance art market, which was expert in producing fakes of antique sculptures, coins and medals.

The fashion for collecting material souvenirs of the past was just one expression of humanism, a cultural and intellectual movement that spread through learned circles in Italy during the fifteenth century. Renaissance humanism placed an emphasis on the value of civic duty, following the exemplar of the ancient Greeks and Romans. Consequently, it encouraged a new sensibility towards the classical world and all its artistic forms. However, original objects

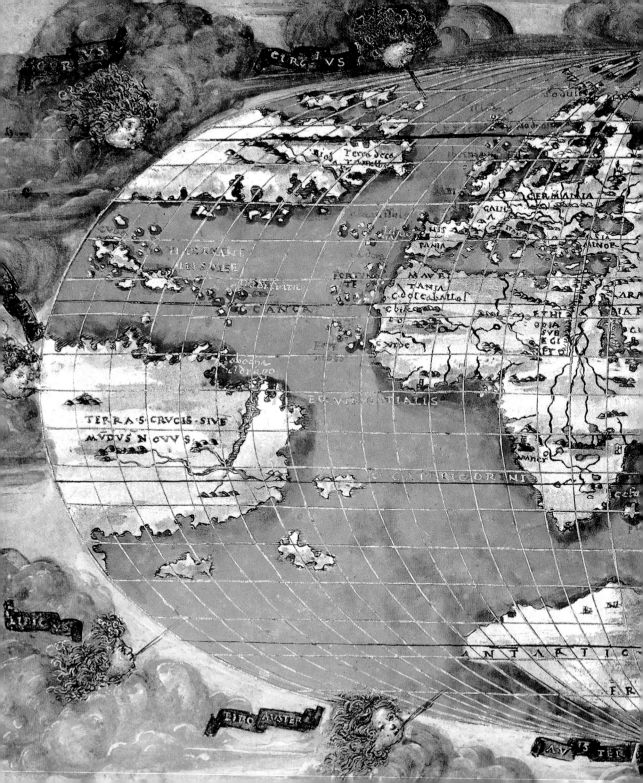

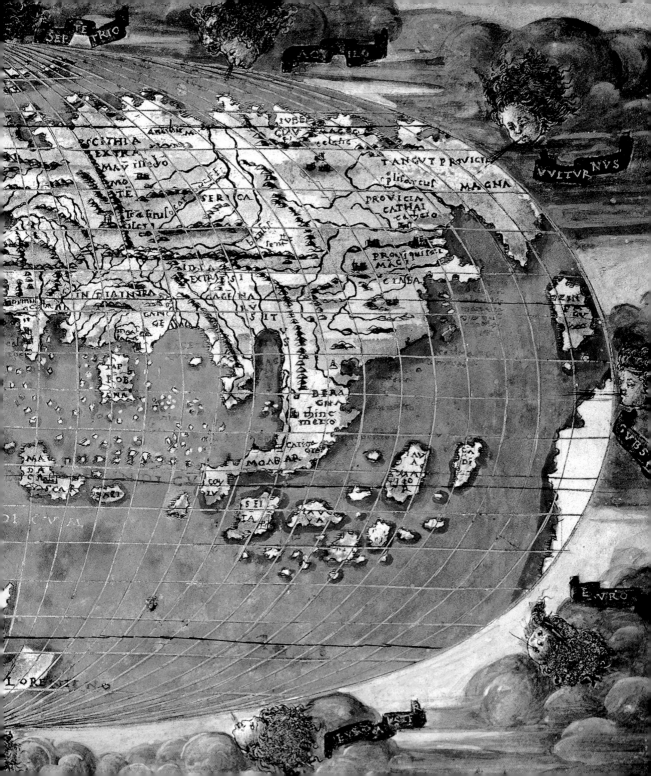

became harder to find and reports began to circulate by the early sixteenth century that Rome had already been stripped of all its treasures (plate 75). Engravings and other forms of reproduction became an alternative means of embracing this taste for classical works of art. Famous Roman sculptures were reincarnated as bronze inkstands for use in the study. Large numbers of these inkstands were made in Padua, a university town outside Venice where humanist influence was strong. Some were intended to be faithful copies, such as this early sixteenth-century example, which

75. Coin of Trajan. Gold. Rome, AD 112–14. V&A: A.680–1910

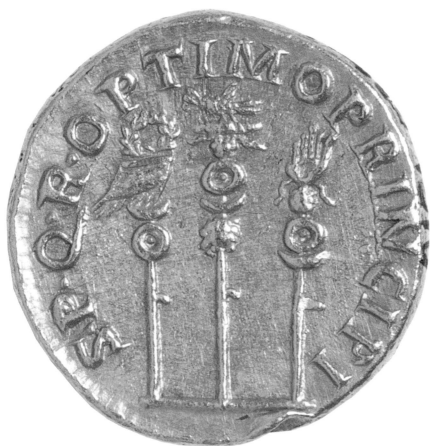

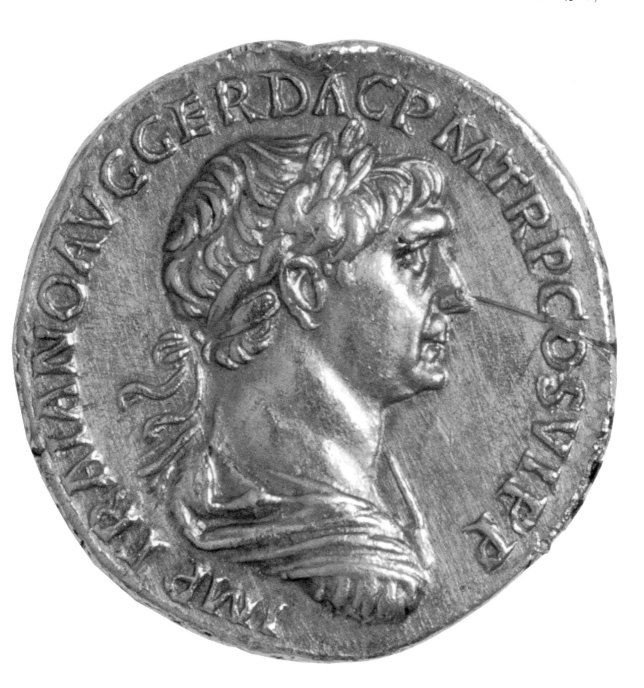

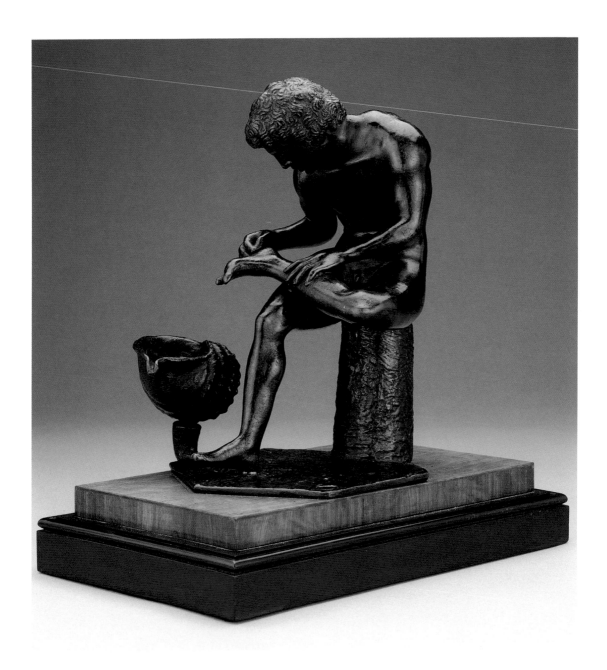

shows a boy pulling a thorn from his foot, made in imitation of the famous Roman bronze known as the *Spinario*, while others gave more of a contemporary twist to their subject (plate 76). Their success led to the production of inkstands in other materials. Similar miniature sculptures were created in *maiolica*, sometimes featuring animals, both real and mythological, or figurative scenes, such as these two fishermen hauling in their nets full of fish (plate 77). As

76. Workshop of Severo Calzetta (Severo da Ravenna),
Inkstand with the *Spinario*.
Bronze. Ravenna, *c*1510–30.
Ashmolean Museum,
Oxford, WA 1899.CDEF.B1078

77. Possibly by the workshop of Patanazzi, two-piece inkstand in the form of a boat with fishermen.
Earthenware. Urbino, *c*1580–90.
Philadelphia Museum of Art,
Inv. 1999-99-2a,b

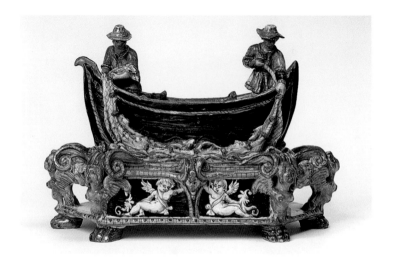

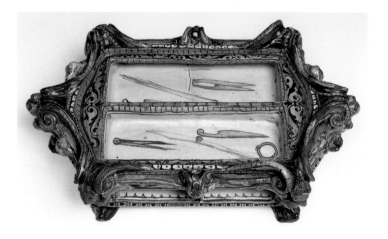

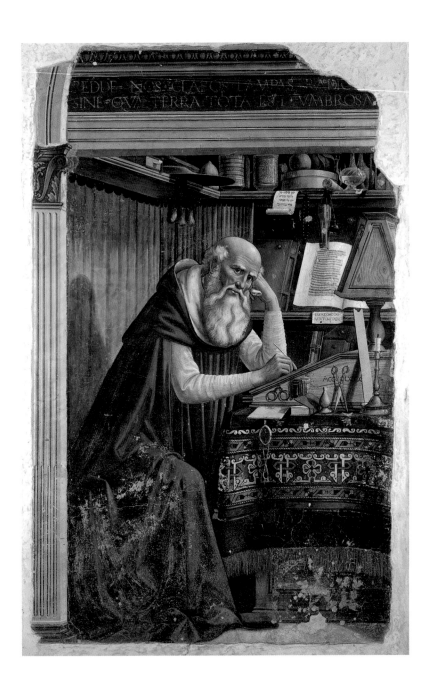

78. Domenico Ghirlandaio,
St Jerome in his Study.
Fresco. 1480.
Ognissanti, Florence

often happened during this period, practical items had the potential to develop into things of extreme beauty, and the inkstand took on such an ingenious variety of forms that sometimes it must have been difficult to guess its true purpose.

Many possessions kept in Renaissance studies would rarely be found in their modern-day equivalents. Antiques were not the only choice for the study; indeed, some objects were particularly in demand precisely because they were in some way novel, often made using innovative techniques or materials. This is one explanation for the frequent appearances of glass and *maiolica* goods in inventories and paintings of studies. These included jars of the kind also used in pharmacies to store spices and herbal remedies, two of which can be seen on the shelves in St Jerome's study in a fresco by Domenico Ghirlandaio (plate 78). They are placed alongside various Venetian glass vases, another product that was constantly being improved and taking on new forms. Unusual objects brought back from foreign countries were also popular, including damascened metalwork from Turkey and ceramics from Moorish Spain. Models of the heavens, such as armillary spheres and astrolabes, reflected a fascination with the movements of the planets, the sun and its relationship with the earth (plate 79). These were all 'talking-pieces', intended to stimulate conversation and intellectual exchange. With a mixture of classical works of art, medals, gems, modern glass and ceramics, as well as curiosities from the natural world, thought-provoking connections soon developed between very disparate objects.

These items were sometimes arranged on just a few shelves or perhaps filled a corner of a room. In other cases, a whole study was conceived with a view to presenting a collection in a logical fashion. Meticulous organization was vital for the sixteenth-century Venetian Andrea Vendramin, whose collection was truly vast. His was one of the first to be fully catalogued and the resulting work totalled no fewer than 16 volumes. This ink sketch taken from the catalogue shows that his study was crammed with objects, from ceiling to floor. At the same time, the room was designed to produce a highly decorative appearance, since small shelf compartments

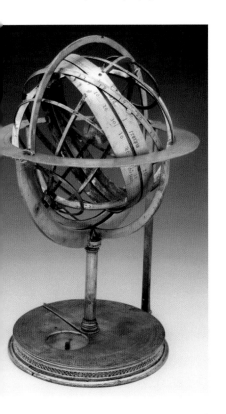

79. Armillary sphere.
Brass. Italy, *c*1500.
Museum of the History of
Science, Oxford, 12765

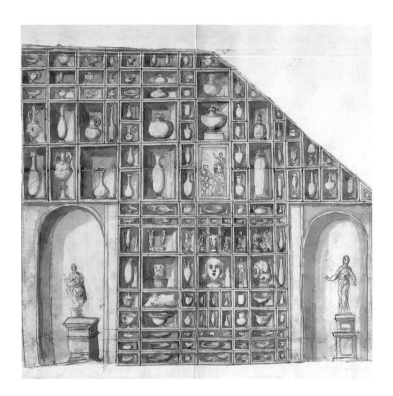

80. Sketch of a wall of Andrea
Vendramin's study from the
catalogue of his collection,
*De Sacrificiorum & Triumphorum
vasculis, lucernisque Antiquorum,
Urnis.* Pen and ink on paper.
Venice, 1627.
Bodleian Library, Oxford

81. Sketch of antique lamps
from the catalogue of Andrea
Vendramin's collection,
*De Sacrificiorum & Triumphorum
vasculis, lucernisque Antiquorum,
Urnis.* Pen and ink on paper.
Venice, 1627.
Bodleian Library, Oxford

alternated with larger niches for figurative statues (plate 80). A page
from the catalogue illustrating oil lamps exemplifies Vendramin's
exhaustive approach to building up a collection (plate 81). He
displayed an encyclopedic breadth of interest, which was
characteristic of a trend that extended beyond Italy in the sixteenth
century. The rationale behind these early domestic collections later
influenced the development of the first public museums. Vendramin
ordered objects in different categories and hierarchies, with a view to
understanding and appreciating aspects of society, geography and art,
indeed the world as a whole. Like many other domestic spaces,
Vendramin's study and its contents shed light on the power invested
in material goods during the Renaissance and, above all, the dynamic
relationship between people and things.

LVME ETTERNE.

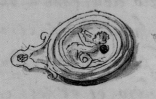 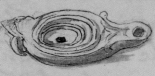 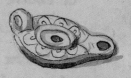

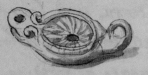 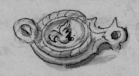 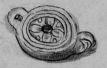

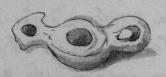 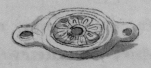 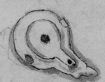

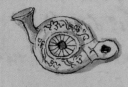 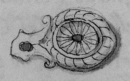 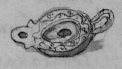

Scriue della materia delle lucerne, il Licetto

FURTHER READING &.

Alberti, Leon Battista, *The Family in Renaissance Florence: A Translation by Renée Neu Watkins of* I libri della famiglia (Columbia, South Carolina, 1969)

Bell, Rudolph M., *How To Do It: Guides to Good Living for Renaissance Italians* (Chicago and London, 1999)

Brown, Patricia Fortini, *Private Lives in Renaissance Venice: Art, Architecture and the Family* (New Haven and London, 2004)

Callmann, Ellen, *Apollonio di Giovanni* (Oxford, 1974)

Chartier, Roger (ed.), 'Passions of the Renaissance', *A History of Private Life*, ed. Philippe Ariès and Georges Duby (Cambridge, Massachusetts, 1987–94), vol. III

Dean, Trevor, and Lowe, K.J.P. (eds), *Marriage in Italy, 1300–1650* (Cambridge, 1998)

Goldthwaite, Richard, *Wealth and the Demand for Art in Italy, 1300–1600* (Baltimore and London, 1993)

Hills, Paul, *Venetian Colour: Marble, Mosaic and Glass, 1250–1550* (New Haven and London, 1999)

Klapisch-Zuber, Christiane, *Women, Family and Ritual in Renaissance Italy* (Chicago and London, 1985)

Landau, David, and Parshall, Peter, *The Renaissance Print, 1470–1550* (New Haven and London, 1994)

Liefkes, Reino (ed.), *Glass* (London, Victoria and Albert Museum, 1997)

Musacchio, Jacqueline, *The Art and Ritual of Childbirth in Renaissance Italy* (New Haven and London, 1999)

Praz, Mario, *An Illustrated History of Interior Decoration from Pompeii to Art Nouveau* (London, 1964)

Rubin, Patricia, and Ciappelli, Giovanni (eds), *Art, Memory and Family in Renaissance Florence* (Cambridge, 2000)

Rubin, Patricia, and Wright, Alison, *Renaissance Florence: The Art of the 1470s* (London, National Gallery, 1999)

Sarti, Raffaella, *Europe at Home: Family and Material Culture, 1500–1800* (New Haven and London, 2002)

Syson, Luke, and Thornton, Dora, *Objects of Virtue: Art in Renaissance Italy* (London, British Museum, 2001)

Thornton, Dora, *The Scholar in his Study: Ownership and Experience in Renaissance Italy* (New Haven and London, 1997)

Thornton, Peter, *The Italian Renaissance Interior, 1400–1600* (London, 1991)

INDEX ❧

Italic page numbers relate to references in illustration captions on those pages.